BARRON'S ART HANDBOOKS

CARTOON

BARRON'S ART HANDBOOKS

CARTOON

ANT

BARRON'S

TABLE OF CONTENTS

**HISTORICAL
REFERENCE**

• **The Significance of Humorous Drawing.** An easy and fun game. The need for satire. *The process of abstraction* . 6–7

• **Satirical Illustration in Ancient Civilizations.** Primitive lines. Naive painting. Fauns and satyrs. *Caricature in Greek theater* 8–9

• **Grotesque Drawings in the Middle Ages.** Illuminated books. A catalog of strange creatures. *Choir lofts and masonry* 10–11

• **Renaissance Caricature.** Burlesque portraits. The invention of cartoons. Leonardo's cartoons. The spread of printing. *Bernini's simplification of features* 12–13

• **British Satirical Illustrations of the Eighteenth Century.** Humorous representation in England and the Netherlands. William Hogarth. Gillray's political influence. *Rowlandson's fluid style* . 14–15

• *Ukiyo-e.* Chojugiga rolls. Ukiyo-e: Japanese illustration. Kabuki theater. *Precedents of the manga culture* 16–17

• **Francisco de Goya.** *The Caprices. The Disasters of War.* Paintings of witches and old people. *"Black Spain".* . . 18–19

• **Humorous Eighteenth and Nineteenth Century French Drawings.** The French Revolution. The great century of French cartoons. Gavarni, a clever portraitist. *Philipon's Pear* 20–21

• **Honoré Daumier.** The painter of cartoons. The oppressed classes. The spread of lithography. *Toulouse-Lautrec and poster art* . . . 22–23

• **Cartoons and the Press.** Popular engraving in the nineteenth century. The century of German cartoons. The popularity of the press. The first satirical magazines. *Posters* 24–25

**PROCEDURES AND
MATERIALS**

• **Paper: Manufacturing and Types.** Types of paper. The best types of paper. Weight. Translucent paper. *Light tables* 26–27

• **Pencils: Hardness and Other Properties.** Mechanical pencils. Hardness and darkness of lead. How to begin. Grease pencils. *Doodles* 28–29

• **Colored Pencils.** Comics and color. Building up color. Small format. Pencil lines. *Illustrating children's stories* . . . 30–31

• **Markers.** Technical resources. Technical characteristics. Shading and blending. *Markers and illustration* . 32–33

• **Drawing with Ink.** An indelible medium. Black and white drawings. Pens and brushes. Inking. *Correction fluid* 34–35

• **Watercolors.** Characteristics of watercolors. Applying a wash. White areas and masking. *Colored inks* 36–37

• **Gouache.** Characteristics and use. Explosions of color. Gouache and professional illustrators. *Gouache technique* 38–39

• **Acrylic Paints.** Characteristics of the medium. Transparent paint. *Illustrating with acrylic paints* 40–41

**TECHNIQUES AND
PRACTICES**

• **Composing the Human Figure.** Study of proportions. Realistic understanding. A sketch of the human body. Anatomy is essential. *The "plan"* 42–43

• **Rules for Physical Distortion.** Distortion with ovals. Types and characters. *Rotating the character* 44–45

• **Basic Factors in Humorous Representation.** The psychology of the characters. Choosing the type. Exaggeration and contrast. *A good observer* 46–47

• **Arms and Legs.** Drawing the arm. The lower extremities. *Women's extremities* 48–49

• **Hands and Feet.** The hands. The feet. Sketches and distortion. *Eliminating one finger* 50–51

• **The Head.** Composing the head. Drawing from the general to the specific. *Disproportionate size* . . 52–53

• **Facial Expression.** Studying Physiognomy. Astonishment, delight, and attention. Derived expressions. *Supporting graphic signals* 54–55

• **The Ages of a Human.**
Babies. Children. Adults.
Older people. *Sensuality and
eroticism*.......... 56–57

• **Body Language.** Expres-
sions and gestures. The most
common postures. Analyz-
ing posture using ovals.
Dress............. 58–59

• **Figures and Background.**
Space and perspective. Back-
drops. Aerial perspective.
Creating atmosphere.. 60–61

• **Action and Movement.**
Exaggeration of form. The line
of action or force. Graphic
resources. Kinetic lines.
Simultaneity of action.. 62–63

• **Styles.** Types of distortion.
Naturalistic style. Psychologi-
cal style. Decorative style.
Conceptual drawing.... 64–65

• **Style and Creativity.** The
search for a personal style.
Stylistic variety. Looking for
comical situations. *Represent-
ing objects*........ 66–67

• **Sketches and Experimen-
tation.** Experimental doodling.
Continuous lines. The finished
drawing. *Technical pens*. 68–69

• **Character Development.**
Different visions..... 70–71

• **Mastering Line: Pen and
Ink.** Pen drawings. Lines drawn
with nibs. Comics. *Erasing
with a razor blade* 72–73

• **Lines Made with a Brush.**
Line quality. Filling in black.
Frottage. Varied line weights.
Block style.......... 74–75

• **Lighting.** Shadows on
objects. Silhouettes. Simpli-
fying shadows. Shading with
color. *Combining line and
color* 76–77

• **Concerning Illustration.**
Variety of styles. Cartoons.
Commercial illustration. *Poster
art* 78–79

• **Coloring Techniques.** Color
choice. Light washes. Opaque
paints. Drying times. *Coloring
with the computer* 80–81

• **Special Effects and Tricks.**
Wet on wet. Creating high-
lights with bleach. Wax resists.
Washes with salt. Scraping.
*Exaggeration of perspective
and foreshortening* 82–83

• **Caricature.** The satirical
effect of caricature. Human
expressions. Minimal indica-
tions of expression. *Naturalis-
tic models*.......... 84–85

• **Caricature: Studying the
Character.** Good photo-
graphs. Doodles. Abstract-
ing the most characteris-
tic features. *Capturing the
psychology* 86–87

• **Caricature in Pencil:
Winston Churchill.** Struc-
ture. Basic construction of the
face. Defining the most char-
acteristic features. Shading.
Three-quarters view ... 88–89

• **Caricature in Watercolors:
General de Gaulle.** Geo-
metrical layout. Coloring with
washes. Creating shapes with
washes. Outlining with pen
and ink........... 90–91

• **Caricature in Markers:
Marilyn Monroe.** Pencil
sketch. Drawing the outline.
Highlighting the features.
Final shape and volume
effects 92–93

• **Caricature in Ink: Orson
Welles.** Process of analysis.
Preliminary washes. Painting
the clothing. Lines in India
ink.............. 94–95

THE SIGNIFICANCE OF HUMOROUS DRAWING

In humorous drawings, graphics need not reflect nature, so one need not learn drawing from reality. Satirical, comic, or grotesque caricature springs from the artist's creativity.

An Easy and Fun Game

Graphic humor may be the most specialized type of all, because it has to reflect a person's cleverness and humor principally through exaggerated graphics. This often turns into an easy and fun game, because in spite of the methods and techniques, humorous drawing exists over and above any rules. This is a type of illustration in which the technical aspects are less important than the creator's ingenuity and talent.

Good graphic humorists are important figures in periodical literature; not only does their work enjoy greater loyalty on the part of the readers than that of the other contributors and authors, but it also becomes a sort of "trademark" for the publication.

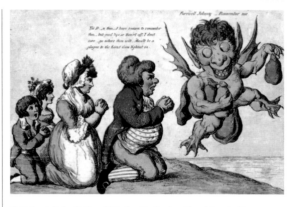

P. Roberts, John Bull and His Family Saying Good-bye to Taxes, 1802. Etching and watercolor engraving.

Richard Newton, Treason!!!, 1798. British Museum, London.

The Need for Satire

Satire and humor are relaxing forms of expression that must be simple and understandable, and at the same time stimulate the observer's imagination. In spite of using informal esthetic values, such

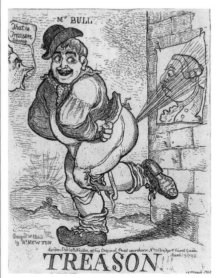

Abstraction and stylization of features are crucial factors in humorous drawing. Illustration by Montse Asensio.

The Process of Abstraction

Humorous criticism requires a sort of distillation of a person, object, or situation. The satirical or humorous factor results in a distorted or adulterated image. The characteristics of graphic humor are esthetic exaggeration and functional simplification. Caricature is the expression of an individual's personality based on external features. Caricaturists don't reproduce *what they see*, but rather express an opinion about the models, and that is the source of the fascination that their job holds: a humorous interpretation of the story written on every face.

Caricature is a process of distortion that accentuates the subject's physical and psychological features. Illustration by Anthony Garner.

as ugliness and monstrousness, behind every humorous drawing there is always a psychological and artistic basis, which the illustrator must know and interpret successfully.

The humor and comical aspect of a drawing are based on "the pleasure we experience in contemplating the contrast between the real and the implausible, or between the unexpected and the inappropriate." Irony is characterized by the difference between what is said and what is truly meant. Satire contains an ethical and higher purpose—to educate or correct—and its ultimate goal is to censure, criticize, or ridicule people, institutions, things, and situations. It uses every resource from laughter to indignation.

For other people, the comic element is due to a "logical contradiction" that makes us laugh when we come up against it. Because of the need to make the irony and the criticism in the drawings intelligible to the observer, the illustrator must keep abreast of current events and make use of the political, social, and cultural features that can prove useful in the creative process.

A humorous drawing combines a technical mastery of illustration plus visual and satirical acuity. Illustration by Anthony Garner.

SATIRICAL ILLUSTRATION IN ANCIENT CIVILIZATIONS

The practice of representing deformed people and animals to show them at their most comical is as old as civilization itself. In past ages, humans revealed their talent for graphic representation on the walls of their caves, on papyri and in the exquisite decoration of their pottery, often introducing visions of irony and humor.

Primitive Lines

Several thousand years before the appearance of writing, artists had created drawings and carvings of animals and grotesque, deformed people. These figures were assumed to have magical powers that would favor the hunt and increase crop yields. Most of them are very naturalistic, even when they use such exaggerated shapes, but with time the primitive artists developed very schematic and stylized abstractions of the models.

Naive Painting

The work that is considered to be the true origin of cartoons is the famous *Concert of the Animals,* which was painted on a sheet of papyrus preserved in Turin, Italy. It depicts a lion playing chess with a gazelle, and a dog tending a flock of docile goats. It also represents several animals playing different musical instruments, such as a

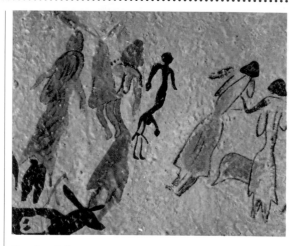

Even though they serve a ritual rather than a humorous purpose, the earliest figure distortions occur in prehistoric art. Hunting scenes from the Cogull Cave (Lleida, Spain). Archeological Museum, Barcelona.

donkey, a lion, a crocodile, and a monkey, in a luxurious setting. In Ancient Egypt, during the eighteenth dynasty, cartoon art reached new heights of popularity. At that time the reforms of Amenophis IV (Akhenaton), which entailed many changes, gen-

erated strong criticism; some graffiti found on the ancient walls of Thebes are similarly famous. The realism of Egyptian sculpture from the period also depicts the pharaoh Akhenaton with strongly exaggerated features that are nearly cartoon-like.

The oldest known humorous vignette: The Concert of the Animals.
Paint on papyrus. The Egyptian Museum, Turin, Italy.

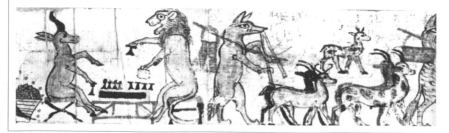

The Significance of Humorous Drawing
Satirical Illustration in Ancient Civilizations
Grotesque Drawings in the Middle Ages

9

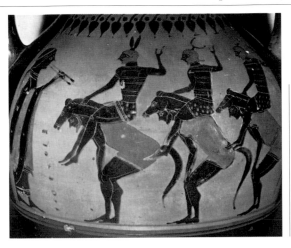

Greek ceramics depicting people disguised as horses and carrying riders on their backs.

amics, and were therefore very distant from "official art," and that gave them the greatest liberty to demonstrate their genius.

A similar situation existed with the Romans, with painters such as Calates, Bupalos, and Athenis. Paintings that represent comic scenes have been found in the cities of Pompeii and Herculaneum.

Fauns and Satyrs

Greco-roman culture is rich in cartoons, and their evolution corresponds to various concepts in their philosophy pertaining to what constitutes "comical." Universal satirical types were created during classical antiquity; these include the Faun, Silenus, Bacchus, the Harpies, and others. The Greco-roman satirical vein took the form of burlesque-like scenes applied to vases and objects of domestic use. Through references by Aristotle and Aristophanes, we know of the painter Poson, who satirized the people he represented by "bringing out the worst in them." These artists were painters of cer-

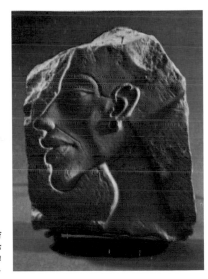

Portrait of Akhenaton. *Bas relief. British Museum, London.*

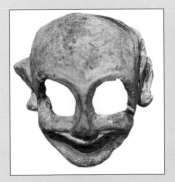

Caricature in Greek Theater

The tolerant views of the Greeks in Antiquity gave rise to many comical and libertine theatrical representations. On the other hand, there are quite a few ridiculous figurines from the Hellenic period that recall the masks and the character types of Greek farce and new comedy. Within the framework of comedy, theatrical masks occupied an important position and came to be used in carnival celebrations and Dionysian bacchanals.

Masks acquired great importance among Mediterranean cultures in many types of festivities and theatrical productions.

GROTESQUE DRAWINGS IN THE MIDDLE AGES

The predecessors of humorous illustration as we know it today are found in the miniatures that medieval artists used to decorate manuscripts. Often the characteristics and activities of the people and animals were exaggerated in these images to create a comical and shocking effect on the reader.

Illuminated Books

Miniatures were often very detailed, richly colored, and done with great care, and could be considered true works of art. They were originals, but they were very similar to works made using modern reproduction techniques, incorporating a perfect blend of text and image. Many times these images are intentionally comical, as with the Flemish *Book of Hours* from the fourteenth century, in which the men who are preparing to attack a castle have been replaced by animals.

Slightly comical portrait of the pope and the emperor Charlemagne joined together as rulers of the world.

A Catalog of Strange Creatures

Throughout the centuries there has always been an esthetic of the grotesque, the horrible, and the exaggerated that combines fears and magical spells, in both primitive and avant-garde art. Christianity used representations of misshapen beings and animals as

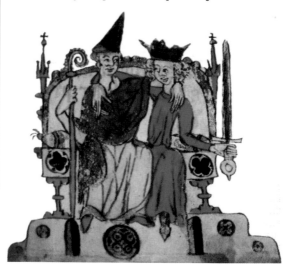

Choir Lofts and Masonry

In the medieval church religious and divine images had their place in the altarpieces and side chapels, but space was also reserved for some grotesque and deformed shapes which remained hidden from spectators who failed to look carefully. Medieval caricature took the form of masks, monsters, mythological figures, dragons, and so forth, on capitals, flying buttresses, and in carvings in the choir masonry, and also in the shape of fantastic animals and satirical caricatures, gargoyles, and caryatids. These scenes were filled with truly amusing cunning, eroticism, and brazenness, which contrasted with the sterile and serene images of the religious carvings that predominated in the church.

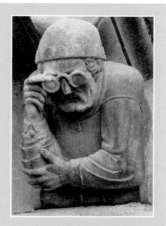

Satirical Caryatid. *Cervera Town Hall (Lleida, Spain).*

The Attack of the Animals. *Flemish* Book of Hours, *fourteenth century.*

Juan de Mandeville, *depictions of fantastic creatures in the Book of the Wonders of the World and the Holy Land. Valencia, 1521.*

symbolic of other realities. The illuminated codices into which these figures were incorporated showed an interest in strange and diabolical creatures as contrasts to good. The expression of these images is intense, and they sacrifice reality in favor of the grotesque. That lends great expressive significance to the size of the eyes, the fangs, and the claws, as well as the bright colors used by the artist in each illustration. Some subjects in particular, such as the devil, the dance of death, hell, the final judgment, the vices of men and women, their sins, and so forth, become true sources of inspiration.

On the other hand, the discovery of the new American lands and the tales of the explorers who returned from Asia and Africa gave rise to fantastic stories about new races, legends, and animal types, a fertile ground for the imagination.

The Dragon and the Beasts Thrown into Hell. *The Cloisters. Metropolitan Museum of Art, New York.*

RENAISSANCE CARICATURE

In the strictest sense, it can be said caricature as we know it was developed during the Renaissance. It was based on the work of earlier artists, if we go by the etymological sense of the word, which comes from the expression *ritratti carichi* ("elaborate portraits").

Burlesque Portraits

During the Renaissance burlesque portraits were common among painters and sculptors. They were created in a light-hearted vein and they aimed at achieving a certain resemblance to the person they mocked. The artists exaggerated the physical defects of their subjects in order to ridicule them or to have fun. The point was not to highlight ugliness as a vice, as was done in the Middle Ages, but to use the ugliness as an esthetic technique, as a counterbalance to the classical idea of beauty.

Leonardo da Vinci, Grotesque Figures. Ambrosian Library, Milan.

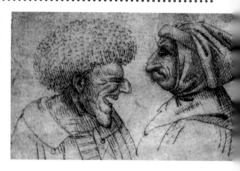

The Invention of Cartoons

Cartoon-like portraits, or comical distortion as we know it today, originated in Bologna at the end of the sixteenth century in an art school founded by a family of refined academic artists, the Carracci brothers. They were the first ones to make a joke of transforming their victims' heads into those of animals and caricaturizing their features. Then

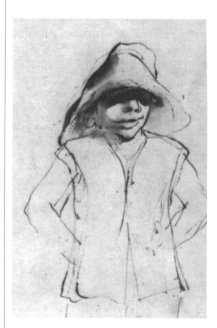

Pieter Breughel, Figure Study. Drawings Department, The Louvre, Paris.

Il Guercino, Caricature of a Boy Wearing a Large Hat. Art Museum of Princeton University, Princeton, New Jersey.

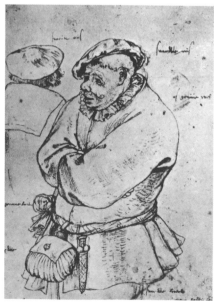

Grotesque Illustration in the Middle Ages
Renaissance Caricature
British Satirical Illustrations of the 18th Century

13

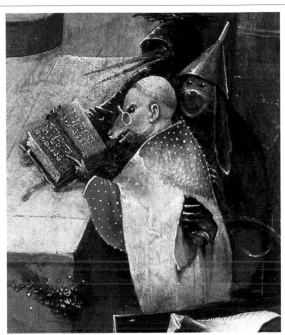

Bosch, The Devil Dressed Like a Priest. The Temptations of Saint Anthony (detail). National Museum of Ancient Art, Lisbon.

The Spread of Printing

The development of printing during this period surely had an influence on the evolution of caricature, and that made possible two basic accomplishments in this genre: on the one hand, the possibility of recovering costs, since it made cartoons more accessible and popular; and on the other, it was the way to increase the speed and distribution of these drawings. Starting with the invention of printing, satirical engravings were done on wood and included image and text on a single plate. This printing technique initiated the magnificent age of humorous drawing in Europe.

other artists followed their example, such as the Bolognese artist Domenichino, the Romans Bernini, Maratti, and Ghezzi, and the Venetians Guercino, Zanetti, and Tiepolo. Three great masters of Renaissance painting in northern Europe would follow them a few years later: Lucas Cranach, Pieter Breughel, and Bosch, who produced several works that contained fantastic creatures.

Leonardo's Cartoons

It would seem that the Carraccis invented cartoons, but it was Leonardo da Vinci who coined and began using this term to define some of his drawings and studies of human faces in which he intentionally distorted and exaggerated his subjects in order to satirize them. In his drawings, Leonardo portrays the deformity of old age, physical degeneration, defects, and vices, especially moral ones. He stresses facial expressions and ridicules attitudes to focus attention on the most degraded intellectual and moral characteristics of the subject.

Bernini's Simplification of Features

One of the most noteworthy examples of Renaissance caricature is found in the works of Gian Lorenzo Bernini; in addition to mastering sculpture and proportions in marble, he demonstrated in his cartoons his skill in simplifying the features of his models.

Gian Lorenzo Bernini, Caricature of Pope Innocent.

BRITISH SATIRICAL ILLUSTRATIONS OF THE EIGHTEENTH CENTURY

In England during the seventeenth century satirical illustrations criticizing the social customs and political events reached a remarkable state of development. Later this art form would culminate in the golden age of caricature in the United Kingdom, with artists such as Hogarth, Gillray, and Rowlandson.

Humorous Representation in England and the Netherlands

William Hogarth, The Port of Calais, 1748 (detail). Oil on canvas. Tate Modern, London.

During the seventeenth and eighteenth centuries, British society had a great vitality and richness. At that time English cartoons were influenced by Dutch engravers because of the many contacts, especially commercial ones, that existed between the two countries. In those centuries humorous drawings had a moral content, somewhat more pronounced on the British side, which later gave way to an increased interest in political satire as the eighteenth century became the nineteenth. The two schools began to separate from one another in the eighteenth century, since the political situations were different in each country.

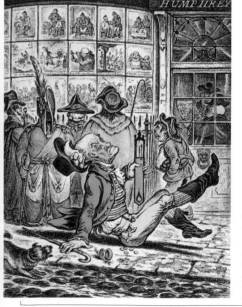

James Gillray, Very Slippery Weather, 1808. Hand-colored engraving. British Museum, London.

William Hogarth

Apart from some seventeenth-century precedents such as Barlow and Hollar, the true initiator of British satirical drawings was William Hogarth, a great observer of social life, who used humor to stigmatize injustice and degradation. Hogarth, whose style was detailed and formal, used his graphic works to deliver biting, moralizing criticism of the licentious customs of certain sectors of English society. His short series of pictures entitled *Marriage à la Mode* amounts to a group of comic vignettes, a story in images.

Gillray's Political Influence

James Gillray continued the tradition of social criticism that William Hogarth had inaugurated, but in a more daring vein and with greater political impact. He was a master of the

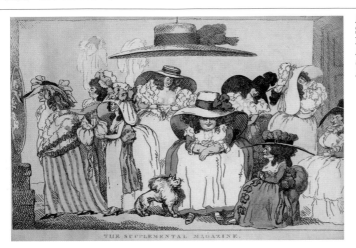

R. Rushworth, The Supplemental Magazine, *1786. Hand-colored engraving. British Museum, London.*

most cutting satire. In his drawings, he portrayed people in the British government and court; oftentimes even the royal family was the target of his biting cartoons. These were characterized by cruel and merciless exaggeration of the subject's personality. The drawings that were printed were monochrome, but if the client desired they could be done in color, since Gillray employed a team of women whose job was to color the engravings by hand. His works were a reference for the graphic humorists who came after him.

James Gillray, George III and Bonaparte. *Etching with watercolor.*

Rowlandson's Fluid Style

The critical vision of Thomas Rowlandson was more amiable than that of Gillray and seemed designed more to please the observer than to transmit political and ethical messages. Rowlandson's drawings were characterized by richness of detail and an obvious fluidity of style. These artists found their main thrust in the mastery of physical characterization and established a level of quality for illustrators in the eighteenth and nineteenth centuries, such as Honoré Daumier in France and Wilhelm Busch in Germany.

Thomas Rowlandson, Italian paint merchants, Humbugging the English Milord, *1812. Engraving with watercolor. British Library, London.*

UKIYO-E

The origins of humorous drawing in Japan go back to ukiyo-e, engravings and woodcuts that became popular starting in the eighteenth century. The subjects centered on the world of *kabuki* theater, baths, bordellos, prostitutes, and in general the pleasure centers in large cities.

Chojugiga Rolls

Since Antiquity, Japan has been connected culturally to China; it adopted its writing system and some customs, along with certain artistic practices. Among the latter are the *chojugiga,* which appeared in Japan during the thirteenth century. These are strips of rolled paper (some of which can reach a length of twenty-five meters), in which anthropomorphic animals that make fun of the Buddhist cosmology are represented in grotesque caricature form. These are abnormal, unhealthy scenes with stories full of suffering. As time went by, these pseudo-Buddhist representations left the strictly religious arena and

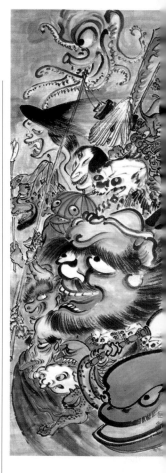

Kyosai, Nightmare of Animals and Chimera. *Ink and watercolor. Private collection, Japan.*

became an instrument of social criticism. The inheritance of these eccentric animals can be found even in the works of the artist Kyosai (active at the end of the nineteenth century).

Ukiyo-e: **Japanese Illustration**

Ukiyo-e is the Japanese art of engraving on wood. The name means "images—or paintings—of the floating world," in other words, the world that flows and passes on. It was popular from

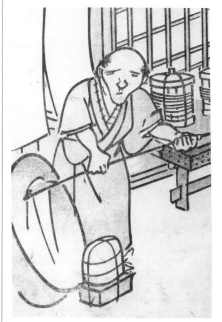

Sato Suiseki, Lamp Maker, *1814. Woodcut. British Museum, London.*

the end of the seventeenth century, around 1680, through the middle of the nineteenth century. *Ukiyo-e* reflected common themes, including famous courtesans and prostitutes, actors in *kabuki* theater, the baths, and bordellos. They parodied Buddhist proverbs on inconstancy and the impermanence of the nature of things. The most commonly

Precedents of the Manga Culture

One of the foremost representatives of Japanese *ukiyo-e* painting, Hokusai Katsushika, coined the term *manga* by combining the syllables *man,* which means *informal* or *uninhibited,* and *ga,* which means *drawing.* But it would be a few centuries later, in the middle of the twentieth century, that modern manga emerged to become the powerful industry that it now is, thanks to the illustrator Tezuka Osamu. Manga has revolutionized the world of comics, developing more realistic stories and creating a stylistic stereotype that is still in force. In fact, we owe to manga drawings the large eyes that are so characteristic in today's illustrations.

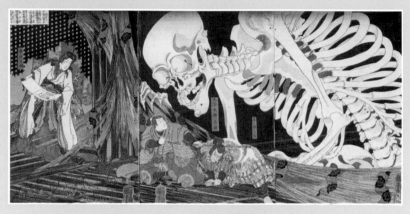

Utagawa Kuniyoshi, Mitsukumi Challenging the Specter of the Skeleton, *1845. Woodcut. Victoria and Albert Museum, London.*

used technique in this school was the woodcut, carved on blocks of cherry wood by expert artisans.

Kabuki Theater

Kabuki theater appeared at the end of the Edo period during the sixteenth century. The actors wore beautiful costumes and presented tragedies and comic situations in colorful sets. It's no surprise that the public began to demand portraits of the favorite actors. Among the many *ukiyo-e* artists, Sharaku created some of the most famous series of portraits of actors between 1790 and 1795; they are characterized by a very personal style with a clearly humorous intention. In the portraits, he magnifies the features to create a tension that borders on the grotesque. Smiles filled with vivacious-

ness, or even a touch of irony, appear on the faces. But this is not an expansive or hilarious humor. It's closer to a vision filled with implicit wisdom about the world and life. The *zen* smile understands that in some way the human stage is

not a drama but an ingenious comedy of misunderstandings.

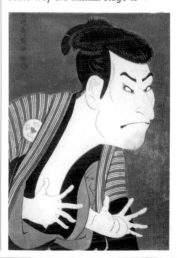

Toshusai Sharaku, The Actor Otani Oniki, *1794. Woodcut. British Museum, London.*

FRANCISCO DE GOYA

The first great representative of graphic humor in Spain was the painter Francisco de Goya y Lucientes. In his engravings *The Caprices* and *The Disasters of War* he unfurled a whole series of deeply critical, satirical, and moralizing commentaries, in a kind of tragic humor that typified European caricature in the age of illustration.

The Caprices

In the collection of illustrations he called *caprices,* Goya set out to ridicule the specific defects of individuals and describe a large number of generalized degenerates, as well as the political abuses that had occurred in Spain up to that time. All types of people are caricaturized in these illustrations: sorcerers, witches, young, old, prostitutes, dandies, monks, doctors, drunkards, mayors, and others. The *caprices* also demonstrate the painter's desire to highlight the subjects' physical, ethical, social, and cultural qualities. Goya was interested in capturing the masses, the popular customs, a multitude that reveals its true colors when it dons a mask and gives free rein to its collective personality.

The Disasters of War

The Disasters of War are a very dramatic and intense series of engravings. In them Goya pulls together his impressions of the Spanish War of Independence against the Napoleonic forces. He portrays the full impact of the violence and barbarity. He caricatures people and brings them to a state of dramatic and anguished distortion. His grotesque figures are always based on nightmares, fantasy, and criticism, often immersed in an atmosphere of terror and gloom. It is a type of uninhibited and somewhat sarcastic hell from which to view daily life with

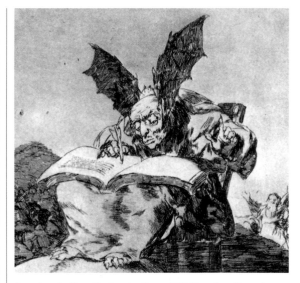

Francisco de Goya, Against the General Welfare, *from the series* The Disasters of War. *Etching and aquatint.*

Francisco de Goya, Caricatures of Monks. India ink and brush drawing.

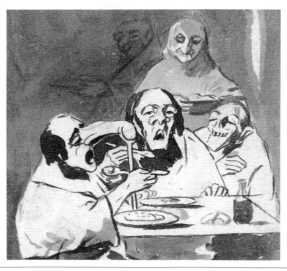

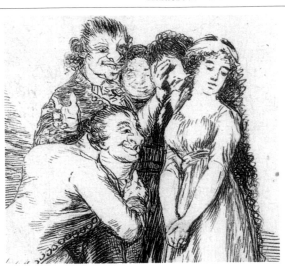

Francisco de Goya, What a Sacrifice (detail), *from the series* The Caprices. *Etching and aquatint.*

he imparts great expressiveness to the faces of deformed, old people, toothless hags, and old sorceresses, focusing on the ugliness that old age brings.

new eyes. For the artist, war is a tragedy; all events are depicted on this tragic horizon, creating an extreme and unbearable mood.

Paintings of Witches and Old People

Even in his youth Goya showed a tendency to use pencils to ridicule human physiology and the most exaggerated features of the people around him. He continued that pursuit in his maturity. The grayish paintings of *The Deaf Man's House* are evidence of that. With broad, loose brush strokes

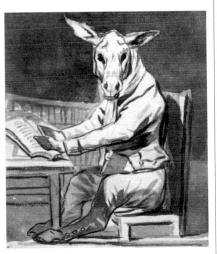

Francisco de Goya, sketch with caricature of a donkey for the caprice entitled To His Grandfather. *India ink and brush drawing.*

"Black Spain"

For European artists, the vision of "Black Spain" found one of its best reflections in the images of *The Caprices.* They loved the fantastic atmosphere that Goya created, which depicts an unknown world inhabited by witches, demons, mysterious beings, and excessive religious fervor. You feel transported to an undiscovered world that is incredible but real. The tree trunks seem to be ghosts; men resemble hyenas, owls, cats, donkeys, or hippopotamuses; priests and monks are contemptible, deformed, and corrupt creatures.

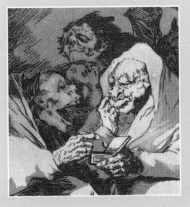

Francisco de Goya, A Lot to Suck On, *from the series* The Caprices. *Etching and aquatint.*

HUMOROUS EIGHTEENTH AND NINETEENTH CENTURY FRENCH DRAWING

In the eighteenth century humorous drawing in France was significant as satire and social criticism. Political cartoons became popular. At first, they encountered serious difficulties with the return of the imperial era, but later they would enjoy great acclaim after the newspaper *La Caricature* was founded.

The French Revolution

At the end of the eighteenth century, the French Revolution heightened ideological passion for political cartoons and printed material, and it changed this burlesque genre into true pamphlets that, even without many resources, could quickly reach the masses and communicate a series of revolutionary messages. Freedom of the press was established, thereby abolishing the obstacle of censorship, and many newspapers and periodicals appeared. This amazing power to spread news had repercussions not only in France, it also crossed national borders in a desire to expand the Revolution, in such a way that the neighboring countries had to increase censorship and control over all publications that came from there.

The Great Century of French Cartoons

Nineteenth-century France developed the genre of cartoons to such a degree that it became the mandatory reference point for the other European countries, taking over from English humorous illustration, which had reached its peak in the eighteenth century. During this time several categories developed in French cartoons: on the one hand, those that originated in envy, rumor, and hatred, true satirical works; and on the other hand, political criticism, the result of such a polemical century. Along with these two currents there was also a third one of a popular nature, richer and more varied, whose aim was the creation of a gentler humor, capable of stimulating thought and producing a smile, in contrast to the former, which in most cases aimed to generate a loud guffaw.

Gavarni, a Clever Portraitist

Guillaume Sulpice Chevalier (1804–1866), known by the name Paul Gavarni, was a very prolific illustrator. His first lithographs date from 1824. Starting in 1830 his works were published in several magazines and afterward in albums at the Aubert firm and in the

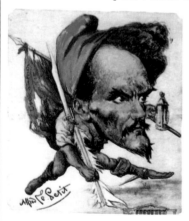

Alfred le Petit, caricature of the political correspondent Henri Rocheford. Black chalk and watercolor.

Gavarni, A Box at the Opera. National Library, France.

Gavarni, Masks and Faces. La Caricature, Paris.

and defects of the *haute bourgeoisie*, which he portrayed in a detailed and good-humored way. Moved by the misery of the lower classes, he began to use a satirical point of view to communicate social problems to the people. Among his most famous works is the series of illustrations on the *Traditions of Women in Sentimental Affairs and Prostitutes.*

Librairie nouvelle. Gavarni specialized in caricaturizing and satirizing Parisian life in several periodicals. He quickly became one of the most insightful graphic humorists in the French capital. Using very realistic drawings, he was an astute observer of the vices

During the French Revolution, vignettes that explained or parodied political life became popular.

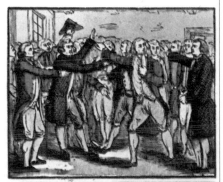

Philipon's Pear

The French cartoonist Carlo Philipon sequentially transformed the head of the King Louis Philippe into a pear in the magazine *Le Charivari* (1834). This is an example of very interesting graphic humor, which allows us to analyze the author's process of creating a caricature; a process of successive distortion and an alternative to the king's portrait, based on a suggestion of equivalency that cost the illustrator a brief stay in jail.

King Louis Philippe characterized as a pear, 1834. Le Charivari magazine, Paris.

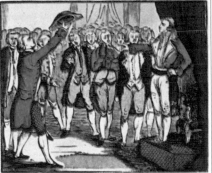

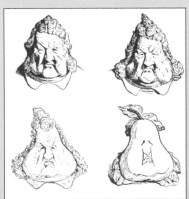

HONORÉ DAUMIER

Known especially for his talent as a lithographer, Daumier was also a painter, sculptor, and cartoonist. He treated caricature and illustration with a deep social and political conviction, using graphic images that were very close to modern poster art. He had a great many imitators, but none of them achieved the depth and intensity of his style

The Painter of Cartoons

In addition to being a painter of undisputed importance, Daumier was a wonderful illustrator. He began his artistic career by drawing advertisements. He was employed in the humorous magazine *La Caricature* and gained fame for the stark political satire of his lithographs. Through his cartoons, he created portraits of types and settings of the age with a critical, broad, and intelligent vision. In one of them, published in 1832, he showed King Louis Philippe I of Orléans as Gargantua (the legendary giant in the works of Rabelais), which earned the artist six months in jail.

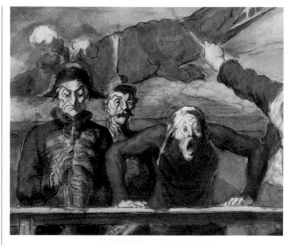

Honoré Daumier, Detail from The Parade, 1867–70. Watercolor and black pencil. Illustration Department, The Louvre, Paris.

The Oppressed Classes

Daumier satirized bourgeois society in a series of lithographs published in the newspaper *Le Charivari,* and he returned to political satire during the Revolution of 1848. His works, which are harsh and dramatic, depict daily life from a viewpoint of very pronounced social protest. He became the painter of the oppressed, the voice of opposition to the bourgeoisie, denouncing in lithographs and paintings all types of situations that struck him as unjust, as befits a realistic painter. But his favorite subject was criticizing the civil employees of the Justice administration. Daumier felt an intense hatred of lawyers and made them one of the main targets of his engravings and paintings. They are always represented by cynical, pompous, and conceited characters.

The Spread of Lithography

The invention of lithography by Aloys Senefelder in 1796 had a major influence on the art of illustration.

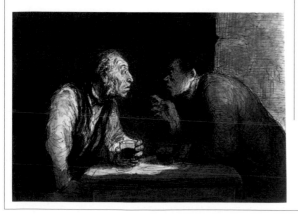

Honoré Daumier, Two Drinkers. Pen, watercolor, and gouache. Musée d'Orsay, Paris.

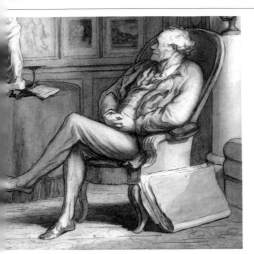

Honoré Daumier, An Amateur. Watercolor and gouache. Metropolitan Museum of Art, New York.

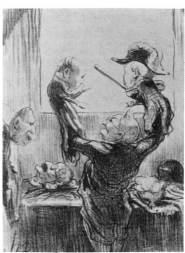

Honoré Daumier. Politicians and Judges Satirized as Puppets. Lithograph. National Library, Paris.

In fact, it involved an important turning point in the production process for humorous illustrations, since up to that time the artist entrusted reproductions to the engraver, and that produced a weakening of the features, if not a poor copy of the original. Now, on the other hand, the artist worked directly on the printing plate, controlling the reproduction process at all times. This allowed drawing with greater fluency and reduced the reproduction costs for greater and quicker print runs from the same plate, which led to greater distribution of satirical illustrations in Europe

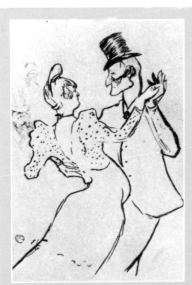

Toulouse-Lautrec and Poster Art

The evolution of illustration and cartoons at the end of the nineteenth century reached a culmination in the works of Toulouse-Lautrec. In his drawings, he renounced photographic precision and concentrated all his attention on the psychological state of the subjects, which led him to exaggerate their features in caricature. Pierre Bonnard, Gustave Doré, and Aubrey Beardsley also were known for introducing cartoon-like and humorous features into their posters and illustrated books. The drawings that these painters produced for various publications, as well as their advertising posters, were a milestone in the esthetic of the age.

Henri de Toulouse-Lautrec, La Goulue and Valentin-le-Désossé, 1894. Lithograph.

CARTOONS AND THE PRESS

Book illustration was given a great boost during the eighteenth century, through the tremendous efforts of French and English illustrated intellectual publications in promoting culture. This would give way in the nineteenth century to romances and periodical publications. Some distinct tendencies appeared in illustration in the middle of the century, with highly differentiated characters and editors who had their own presses.

Popular Engraving in the Nineteenth Century

Graphic illustrations of a popular type became one of the most characteristic genres of the nineteenth century. They included seriocomic formulas that were beginning to develop and that would serve as a basis for the satirical press, which would arrive on the scene not long after.

In this instance cartoons attempted to attract an urbane audience based on a particular type of language; however, they didn't totally abandon the symbolic tradition of certain figures, emblems, and allegories that had arisen in western culture and been spread by academic works. These engravings were anonymous and generally done on wood.

The Century of German Cartoons

German humorous illustrators of the nineteenth century followed the footsteps of the English illustrators until the revolutions of 1848 made possible the appearance of the first satirical weeklies in Munich. At that time cartoons in Germany were of a specific *genre,* drawing its thematic material from politics, social life, and customs. Based on the brilliance of the artists, and thanks to the tremendous diffusion of the satirical newspapers, the nineteenth century has been dubbed "the century of German cartoons." In the

The combatants for liberty have been swept away. German caricature from 1848.

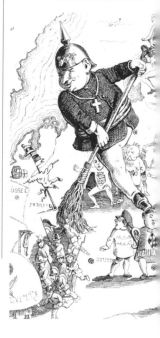

Smith and Laporta, The Comedy of Life. *Popular engraving from 1875.*

Gustave Doré. Facing the World. *Woodcut.*

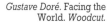

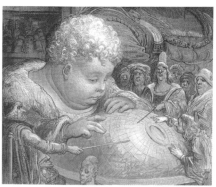

*Pierre Bonnard,
Grotesque Nib,
1895. Lithograph.
La Revue Blanche,
Paris.*

first half of the century, in particular, there were several important artists, such as Oberlander, Heine, and Busch.

The Popularity of the Press

Humorous illustration became tremendously widespread and popular thanks to the press, a fundamental vehicle for the development and expansion of this genre. There was a transformation from the artist-cartoonist to the cartoonist-journalist; in other words, starting at that time, the cartoonists turned into journalists who used the means at their disposal (such as images) in order to reach the masses—masses which, for the most part in the nineteenth century, didn't know how to read and write. That was the main reason for the importance of this medium, which turned into the only one capable of using a popular language that was accessible to everyone.

The First Satirical Magazines

In the middle of the nineteenth century humorous and satirical periodicals began appearing throughout Europe, launching an important generation of cartoonists including Steinlen, Doré, Bertall, and Gill. Periodical caricature is a pictoral genre of opinion through which the artist presents an interpretation of a fact using psychological, rhetorical, and artistic resources, strengthened by a brief text. This art also has a critical and sometimes editorial purpose.

Certainly, this genre has its own structure, generally a "cartoon" or "vignette" (the precursor of comics in 1895) that frames the purpose of the cartoon and delivers a judgment or expresses an opinion.

The formal aspects of the genre are heightened or grotesque features in the drawing, and the balloons containing the captions or dialogs; these, however, are not essential.

Posters

The second half of the nineteenth century was the golden age of narrative illustration, the high point of illustrated posters and all types of graphic propaganda. With the introduction of the advertising poster, the streets were turned into a new artistic environment for humorous drawing. The satirical illustrations that appear on these posters are distinguished by stylized forms and influences from Japanese prints.

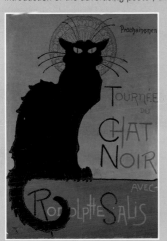

*Théodore-Alexandre
Steinlen, The Black
Cat. Advertising
poster. Museum of
Decorative Arts,
Paris.*

PAPER: MANUFACTURING AND TYPES

Along with the art materials, paper is the main ingredient in an illustration. Therefore, it requires very special attention, and consideration for the main characteristics that become important when the drawing is being made. In fact the final product will vary quite a bit, depending on the weight, the ability to hold the media, the saturation, and the texture.

Types of Paper

Drawing papers can be divided into two basic types: industrial and craft. There are, however, various qualities that exist within these two categories, which depend on the purity of the raw materials, their sizing, the pressing of the sheet, and its final finish, as well as the weight of each type of paper. Drawing paper is identified by weight; the thicker the sheet, the greater its weight. Depending on the technique to be used, one type of paper or another is a better choice, since they are available in textured or smooth finishes.

The Best Types of Paper

The best types of paper for drawing in pencil are ones with a slightly textured surface; for ink drawing, on the other hand, smooth papers with a hard surface are a better choice. The smoother the surface, the easier it is to draw precise lines; textured suports, on the other hand, will produce more rough and imprecise lines. The thin, light lines of colored pencils are hard to see on

Every paper has its use and is suited to a specific technique depending on its weight and texture.

textured surfaces, or on surfaces that are darker in color than normal white paper. In addition, if colored pencils are used on very textured papers, they will show the texture and not be able to produce dark areas of color. This is why professionals commonly use smooth papers without much texture.

Weight

At higher weights, paper is thicker, and consequently stiffer. It's very easy to put a hole into excessively delicate paper while drawing with the point of a pencil, so special care is required in working with lightweight papers. Fine-textured paper will show the

Tracing paper makes it easy to trace and adjust the characters in working up the final illustration.

Light Tables

The easiest way to do a tracing is to use a light table. This is a flat box with a white, translucent glass or plastic top. Several fluorescent tubes are lined up inside the box. With the tubes turned on, the surface of the box becomes very bright and makes it easier to trace when using fairly heavy papers.

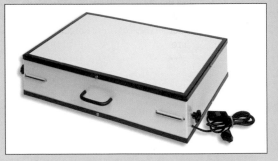

Light tables come in different sizes, and they can always be made at home with a little ingenuity and patience.

A light table is a box with fluorescent lights inside; it makes it very easy to trace original drawings.

different gradations of pencils, producing shading and diaphanous lines of great quality, whereas heavier paper interrupts the lines and strokes, giving them a more broken and ragged appearance. This produces a rougher shading that gives the drawing a much more atmospheric effect.

Translucent Paper

You can buy translucent paper that allows tracing or superimposing several images. This paper, known as onionskin or tracing paper, makes it possible to see the drawing beneath it, which is important if changes or features have to be added to the original drawing.

Tracing paper is used in working with graphite pencils and ink, but it's less suited to other wet media such as watercolors and gouache, since it tends to buckle when damp.

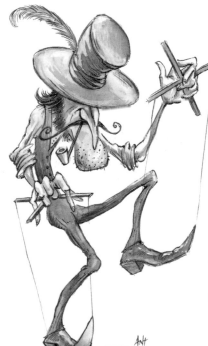

Fine paper makes it possible to produce a detailed drawing. It's the best type of paper for working with pen and ink. Illustration by Anthony Garner.

Paper with a coarse texture produces a rough appearance in the drawing and broken areas of color. Illustration by Montse Asensio.

PENCILS: HARDNESS AND OTHER PROPERTIES

Pencils offer a broad range of colors, and have the added advantage that the drawing can be modified while it's in progress. There are soft, hard, grease, water-soluble, and other types of pencils. It's important to know the different types and their properties in order to make the most of this medium in producing satirical drawings of people.

Mechanical Pencils

The graphite lead held in a mechanical pencil is one of the most popular drawing tools, both among artistic illustrators and illustration professionals. It's the most immediate type of drawing, versatile and sensitive, just as appropriate for a quick sketch as for a detailed work. On the paper, the graphite lead is smooth and velvety when it is applied to shading, or else dark and bold, when the artist bears down on the point. The illustrator also has very precise control of the line, since it's easy to erase and resume drawing.

Hardness and Darkness of the Lead

Leads are classified according to their degree of hardness. For a shaded drawing, soft leads are a good choice, ranging from HB to the highest ranges of B. The ones that belong to the H range, the

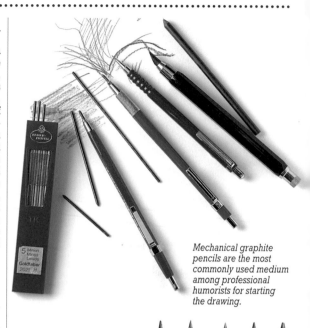

Mechanical graphite pencils are the most commonly used medium among professional humorists for starting the drawing.

hardest ones, are used for technical illustrations and finish work on preliminary sketches. In certain cases, it's convenient to alternate leads of different

Graphite comes in many different forms, from square leads to grease pencils. Each one produces different results.

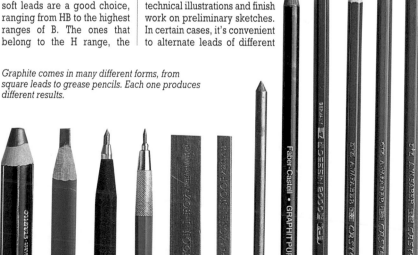

Graphite is an ideal medium for sketching and experimenting. Illustration by Anthony Garner.

hard to erase or cover up later on. Afterwards we can use an HB lead to add details and suggest areas of light and shadow. As in the previous case, if we press down too hard we will create difficulties in erasing on the drawing later. If the drawing is to be inked, it is preferable not to use pencils with very soft leads, because these could leave too many graphite particles, which would smudge the paper when erasing and later interfere with ink absorption.

Grease Pencils

There is a type of pencil in which the lead is slightly greasy, and which can be used to create shading from the most subtle to dark, opaque planes. The grease pencil makes it possible to draw on all types of surfaces, so it is a good choice for preparatory works on which graphic techniques such as acrylics will later be used. Also, when a waterproof grease pencil is selected, it can be used to lay out the strokes for drawings that will be completed with watercolors, since the grease of the lead will repel the water.

gradations, thereby reproducing everything from the most delicate light to the darkest and deepest shadow. Drawings done in pencil have to be protected with a fixative to keep them from smudging, especially when the softer leads are used.

How to Begin

If we are going to use graphite for drawing, we generally need to start the drawing with at least a moderately hard H lead, without bearing down too hard on the paper. Too much pressure leaves marks that are

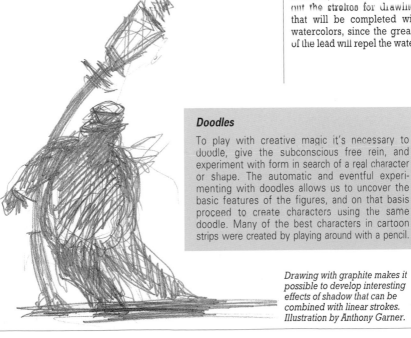

Doodles

To play with creative magic it's necessary to doodle, give the subconscious free rein, and experiment with form in search of a real character or shape. The automatic and eventful experimenting with doodles allows us to uncover the basic features of the figures, and on that basis proceed to create characters using the same doodle. Many of the best characters in cartoon strips were created by playing around with a pencil.

Drawing with graphite makes it possible to develop interesting effects of shadow that can be combined with linear strokes. Illustration by Anthony Garner.

COLORED PENCILS

The properties of colored pencils allow us to bring together in a single work some of the most basic resources of drawing and color effects. The expressive possibilities of this medium are ideal for practicing, investigating, and discovering the nature of colors, how they are mixed and blended, and their variations, to gain a thorough knowledge of the material and techniques.

Comics and Color

Illustrators use colored pencils as a work medium. They have several advantages; these include the possibility of bringing the illustration to a very high level of detail and the permanence and constancy of the colors.

Whether or not the illustration is realistic in nature, mastery of drawing is an essential requirement for every illustrator. Usually an illustrator needs to be versatile in representing all kinds of subjects, so it's crucial to have plenty of flexibility in this broad field.

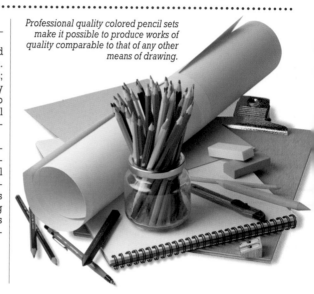

Professional quality colored pencil sets make it possible to produce works of quality comparable to that of any other means of drawing.

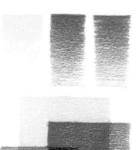

In coloring with colored pencils, mixtures are produced by superimposing thin layers.

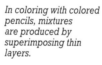

We can also produce mixtures by superimposing crosshatching of different colors.

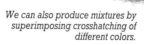

Building Up Color

The most notable characteristic of a drawing done in colored pencils is the subtle optical mix that they produce. A large part of the interest that a colored pencil illustration offers is the richness of intensities of each shade, more than the brilliance and variety of the colors, and the fact that the colors combine optically on the ground itself when shading is used. These layers have to be thought out in advance and follow a specific order: light colors always go over dark ones. This is because light shades don't cover as well and allow the base color to show through, which is a requirement in producing the final color.

Small Format

Colored pencils are an ideal process for making small format originals, since the darkness of the colors and their covering capacity are much reduced in comparison with other procedures.

The advantages associated with these factors include, as previously indicated, the possibility of bringing the illustration to a very high degree of detail and the permanence and constancy of the colors.

Pencil Lines

The first step for every humorous illustrator involves exploring the various types of strokes to become familiar with them before beginning work. We can do that by using the point of the freshly sharpened lead for fine lines, or else the side of the lead for broad strokes.

The weight, the quality, and the nuances of the line can be varied and controlled according to the type of pencil chosen, how sharp it is, and the pressure applied while drawing. With the pencil in hand, it can be tipped to form an angle of thirty degrees or less, thereby producing a broader wedge with the lead that can be used for wider lines. By turning the pencil in the opposite direction it is possible to draw very thin lines.

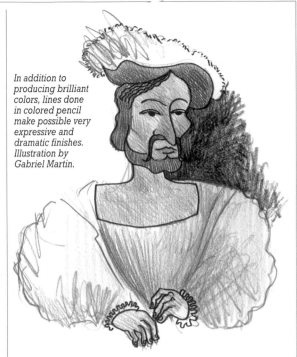

In addition to producing brilliant colors, lines done in colored pencil make possible very expressive and dramatic finishes. Illustration by Gabriel Martín.

Illustrating Children's Stories

Drawings done in colored pencils are very common in decorative illustrations and in children's stories. These illustrations accompany texts as decoration on the page. They often are marginal illustrations that enrich the graphic design of the publication. Closely linked to the overall design of the book or magazine, they are often a technical, explanatory, or documentary complement to the text. We also encounter many illustrations in children's works in which colored pencils and watercolors are used together.

Children's illustrations require pleasant colors and a clear, readable interpretation. Illustration by Montse Asensio.

MARKERS

Artists and illustrators use markers as a medium to create colors with clean, precise tones and a final finish easily reproducible by photomechanical means. The technical possibilities are broad, ranging from dark lines to washed-out color effects that are similar to using a reed pen or pencil.

Technical Resources

The inks in markers are transparent, and like colored pencils, they can be mixed or layered on the paper. When different colors are combined, you have to keep in mind that it is not possible to apply a light color over a dark one; in a drawing the light colors should be applied first, and then the darker ones. This transparency, combined with immediate drying, allows for a technique based on the superimposition of planes, thereby creating different properties and gradations of shading. It's always better to paint using the colors directly, limiting mixing to a maximum of two or three colors. Excessive superimposition of layers would not only damage the paper, but also create a very muddy appearance.

The ink in markers makes it possible to layer shades and colors.

Technical Characteristics

There are two basic types of markers: ones with water-base inks, which are soluble in water, and ones with alcohol-base inks, which are water resistant. Alcohol inks are nearly indelible. In general, markers are not compatible with other media. The point of the marker influences the effect of the lines and patches of color. Conventional markers have a felt tip that makes a line of variable thickness, and which grows broader with use. Polyester tips are much more durable and maintain a constant thickness.

Shading and Blending

It's possible to blend two colors as long as the markers are of good quality and well supplied with ink. The blending has to be done before the first color has dried. The largest areas of the background will have to be filled in with broad-tip markers. The most common practice involves

Markers are a medium that offers many possibilities in the field of humorous drawing.

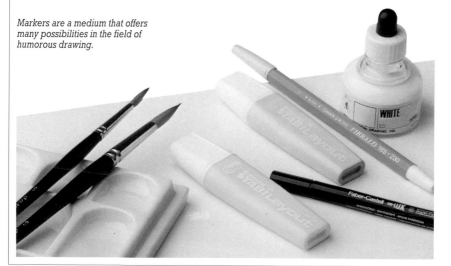

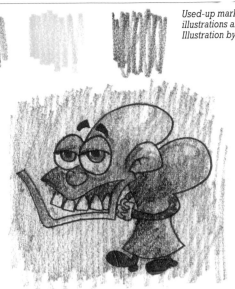

Used-up markers can be used to color illustrations and produce interesting effects. Illustration by Gabriel Martin.

These lighter lines recall the ones made with pencil, and are good for indicating the planes that recede in the distance, or the areas of the drawing that should appear shaded. Therefore, it's a good idea not to throw away the markers that seem to be used up, since they can be very useful in such circumstances.

MORE ON THIS TOPIC

· Coloring techniques **p. 80**

drawing parallel lines, whether horizontal, diagonal, or vertical, and applying them quickly enough for the ink of one line to blend with the next one. Another shading technique that's commonly used involves a sweeping motion that produces an effect based on quick, parallel strokes—in other words, brushing or sweeping the planes that outline or define the surface of the shape depicted. If this sweeping is done very quickly, it can produce an attenuated line.

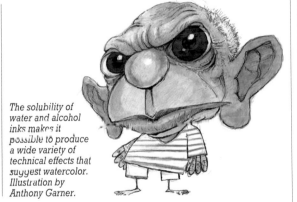

The solubility of water and alcohol inks makes it possible to produce a wide variety of technical effects that suggest watercolor. Illustration by Anthony Garner.

Markers and Illustration

Currently, there are many artists who use markers as an expressive medium, especially in the fields of design and advertising. Some create astonishing results with apparent technical simplicity, but in fact this requires absolute mastery of drawing and color. Markers have long been the medium most frequently used by illustrators to create the closest possible appearance to a printed image. Today computer techniques are replacing this type of application.

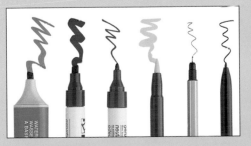

It's necessary to learn how to use the different types of markers to create the most effective line.

DRAWING WITH INK

Ink is the most traditional of all materials used by illustrators. The neat, black line of ink drawings is well suited to reproduction and makes for great precision in the work. In humorous artwork, drawing with a pen is practically a specialty unto itself.

An Indelible Medium

India ink is dark black, but it can be diluted with water to produce a brownish-gray ink. Real India ink is a very intense and slightly satin black. Waterproof once it has dried, it covers very well and is opaque, and it forms a solid and durable film on the paper. Colored inks can be mixed to produce subtle colors.

India ink produces a dark line that gives the drawing an unmistakable quality. Illustration by Anthony Garner.

Black and White Drawings

Nearly all humorous and general-interest magazines include black and white illustrations in their pages. Most newspapers and many magazines use just one ink (black). Artists who do this type of work have to be acutely aware of the medium's limitations, since too much sophistication produces results of low graphic quality. Also, they have to be familiar with the text and identify the point where their style can produce an interesting illustration that is in harmony with the content.

Pens and Brushes

A pen is easy to use and can produce a precise, flexible line that varies in intensity from light gray to black. There are many types of pens, but we recommend the metal nibs that are dipped directly in the ink, rather than drawing pens that have a built-in ink reservoir, since they lack flexibility and don't allow a variety of lines. Artist's brushes are a very flexible drawing medium and are easier to handle than a nib. They can be moved very rapidly and fluidly. Varying

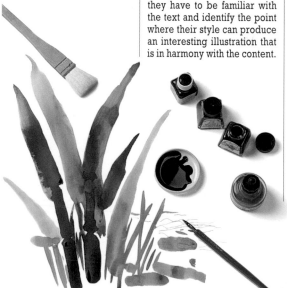

Ink drawing, whether with a reed pen, a nib, or an artist's brush, always produces very attractive results.

Correction Fluid

Once the finished drawing has been inked, the page needs a final cleaning up. First the pencil lines must be carefully erased. You have to proceed with great care, since some erasers are abrasive and may lighten the ink. Spots, lines, smudges, and pencil lines that can't be erased are eliminated with correction fluid. Don't use the same brush as for inking. Correction fluid can ruin a brush used for inking, and the ink can muddy the correction fluid.

Correction fluid is used to cover mistakes in ink.

Inking is a basic requirement for highlighting the outline of the character as well as any details that are worth emphasizing. Illustration by Anthony Garner.

the pressure on the point while drawing produces lines of different widths within a single stroke. That also makes it possible to change direction easily, turning and rounding corners where a pen or a pencil would not serve well.

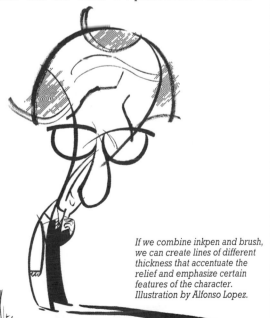

If we combine inkpen and brush, we can create lines of different thickness that accentuate the relief and emphasize certain features of the character. Illustration by Alfonso Lopez.

Inking

In doing a black and white drawing, the inking is the last step. Pens, brushes, and indelible India ink are used for this purpose.

First metal nibs are used—one for fine lines and another for thicker ones. Once all the fine and medium lines have been inked, you can start to use the brush.

Inking with a brush requires practice, but once the technique has been mastered, the effects that can be created are amazing. If the ink is applied to a drawing done in pencil, the finished drawing has to be allowed to dry for several hours before erasing the pencil so that the ink doesn't smear. In addition, a pen should not be used for a drawing that is to be painted, since the inked lines will run in the wet paint.

WATERCOLORS

Coloring drawings with watercolors is a complex subject, but once you have acquired the necessary skill, it becomes a great stimulus to any self-respecting artist. Of all the illustration techniques, watercolors are by definition the most difficult to learn, but in compensation, they also offer the most satisfying results.

Characteristics of Watercolors

Watercolors are available in small containers of semi-moist colored blocks that dissolve quickly when they are moistened with a brush, or in tubes of paints with a creamy consistency. Whatever their form, watercolors are water soluble and transparent; their intensity depends on the degree to which they are dissolved in water. In humorous drawing, watercolors are used for coloring and filling in the carefully drawn shapes. Therefore, the procedure of every illustration using watercolors begins with a well-executed drawing, usually done in fairly hard pencil or India ink. Then it is colored in by using light washes of paint diluted with water, since it's very difficult to lighten a shade of paint once it has dried on the paper.

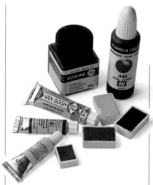

Watercolors are sold in tubes, blocks, and bottles.

be transparent so you can see the ink beneath them. Gradations are created by slightly moistening the area to be painted before applying the paint and extending the color little by little so that it blends with the water and gradually reduces in intensity.

White Areas and Masking

In watercolor paintings, the color white always comes from the white of the paper. For that reason, it's necessary to plan

Applying a Wash

There are two basic ways to apply paints. The first involves glazes, in other words, by means of transparencies: applying one wash on top of another in such a way that it shades or modifies the first color. This is a slow process, since you have to wait for the first coat to dry before applying another; however, this produces shades with great depth and richness. The second method, which is quick and supple, involves working over wet paint, in such a way that the paints seem to move of their own accord and blend on

the surface of the paper. Working quickly lets the artist mix the colors right on the ground, and that requires confident and instinctive brush strokes. The washes blend together, saturate one another, and spread out. It takes practice to control this technique. The colors have to

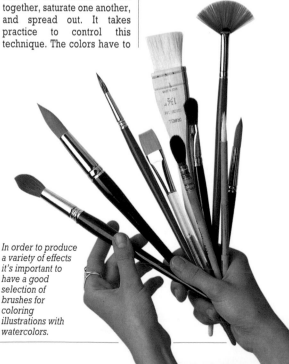

In order to produce a variety of effects it's important to have a good selection of brushes for coloring illustrations with watercolors.

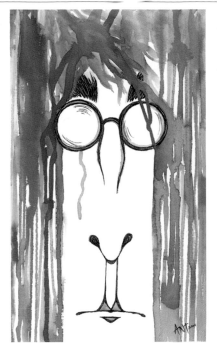

Caricature of John Lennon done entirely in watercolors. Illustration by Anthony Garner.

of the paper. Water-base paint runs off the masked area, leaving the white slightly mottled. There is another easy way to create white areas while the watercolor is still damp: all you have to do is run a clean, slightly moist palette knife over the paint to return the paper to white. And if the desired white area is greater in size, a natural sponge can be used.

ahead for the areas where the white will appear and avoid them when painting. Masking created at the outset with wax or latex rubber keep the wash from getting onto certain parts

Anilines are very intense colors, but they don't have much resistance to light.

Colored Inks

Colored inks or aniline dyes are sometimes used to create dark or brilliant areas of color. The great advantage of these inks is their transparency. They can create transparent and delicate effects by superimposing successive layers of color. You must remember that works done in colored ink are not resistant to light. There is no method for preserving a drawing that is done in this medium. Colored inks are very transparent and can be mixed with one another; they can also be diluted with a little water.

Anilines lend the drawing bright, vibrant colors that contrast with the lines in India ink. Illustration by Anthony Garner.

GOUACHE

Gouaches may be the paints most commonly used by illustrators. They can be diluted with water to create transparent layers or applied as opaque colors. Besides the advantages that this medium offers, we must add the option of combining it with other pictorial techniques, and its perfect suitability for touching up the finish of detailed drawings.

Characteristics and Use

Gouache, like watercolors, is a water-base paint. The basic difference between the two is that gouache colors are opaque. When they come out of the tube or the jar, they appear pasty in consistency. They may be applied directly to the support, but in order to avoid cracking and to create layers of increasingly homogenous texture, they are applied after adding a little water. This makes gouache a less subtle medium than watercolors; still, there is an advantage to the illustrator, since it allows all kinds of touching up and highlighting (which is a bit difficult with watercolors, where retouching is obvious). Colors are lightened not through transparency, but by mixing with white. The finishes of illustrations done in gouache are smooth and velvety, and if the

The opacity and smoothness of gouache make it possible to create colored surfaces having an entirely smooth appearance, in which the effect of the brush strokes vanishes. Illustration by Montse Asensio.

illustrator so desires, all traces of brush strokes can be made to disappear. As a medium for retouching, gouache is prac-

tically unbeatable on all types of illustrations, especially ones that require a high degree of finish and exceptional detail.

Explosions of Color

Areas colored with gouache are explosions of color that can't be created with other mediums, including acrylics. This boldness of color can be put to use in a flat painting or a painting with more depth. In

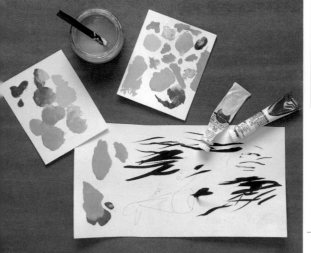

Gouache is an opaque medium that is easy to use and allows color combinations of great chromatic purity.

Gouache Technique

The distinctive quality of gouache is that the illustrator does not need to begin with light shades and gradually increase the darkness; since it's an opaque medium, it can be worked either from light to dark or from dark to light, and it is suited to all kinds of highlighting and revisions.

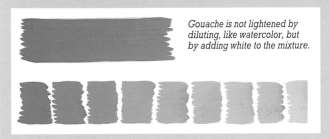

Gouache is not lightened by diluting, like watercolor, but by adding white to the mixture.

the latter case, the brush strokes are used to produce optical mixes that have different chromatic and tonal values. It is not a good idea to use too much white to lighten the shade, since once the illustration is dry it may have a pasty appearance and lack contrast. That's one reason that manufacturers offer such a variety of different colors; by using them right from the tube, the artist is spared from having to create them by mixing with white.

If gouache is highly diluted with water, it produces effects very similar to those of watercolors.

The graphic quality of gouache lies in its opacity and the cleanliness of the colored areas. Illustration by Anthony Garner.

Gouache and Professional Illustrators

Since gouache is a more substantial and a denser medium than watercolors, it can be applied with more energy and resolve, and it can be used in conjunction with many other materials and techniques. Because of their opacity, gouache colors are often used for highlighting all kinds of illustrations, adding details and colors, creating textures, outlining colors, adding pointillist effects, and simply reworking certain areas by superimposing different shades.

ACRYLIC PAINTS

Acrylic paints are recent developments derived from the petrochemical industry. They possess nearly all the advantages of the traditional media and very few of the drawbacks. They are equally appropriate for large-format paintings and for small, delicate studies of animals and miniatures. For professional artists, acrylic paints offer a vast number of possibilities that deserve investigation.

Characteristics of the Medium

Acrylic paints, once dry, are water resistant. They have a short drying time, and the surface is strong and durable. These paints enjoy broad acceptance among illustrators because of their versatility, and especially their quick drying time. These synthetic paints were discovered in the first quarter of the twentieth century, and they combine in a single medium the durability and covering power of oil paints and the fluidity and solubility of watercolors. Their main advantage is that the colors dry very quickly, and they can be painted over very soon. They can also be used very diluted so that they look like watercolors, or they can be applied in thick layers with a palette knife. The result is a film of permanently flexible and waterproof paint that neither yellows nor ages. If the quick drying time is their principal advantage, it is also their greatest disadvantage, since on the one hand it's possible to superimpose layers of paint quickly, but on the other, it becomes difficult to move the paint over the surface of the picture. In any case, and in all types of humorous illustrations, it is always important to work

There is a tremendous variety of acrylic paints on the market and every year new paints appear that broaden the spectrum of possibilities.

With acrylics, many mixes are required to adjust a color; for that purpose, it's a good idea to use several plastic palettes.

on a drawing that is clearly conceived and defined.

Transparent Paint

Acrylic paint is especially well suited for transparent applications, which normally are associated with glazes. The white surface of the ground is reflected through the glazes, and that increases the luminosity of the work. In contrast to watercolor painting, it's worth pointing out that acrylic glazes don't dilute if they are moistened after they dry. A wash made with acrylics doesn't produce an effect as delicate and light as with watercolors, but in compensation it creates very light and deep shades.

Illustrating with Acrylic Paints

A large measure of the success obtained with acrylic paints in the field of illustration is due to the fact that they make it possible to create all imaginable types of finish with great ease: opaque, transparent, satin, textured, earthy, etc. Working with acrylics it is possible to create everything from the effects of strictest realism to the most expressionistic and imaginative finishes. Many illustrators use acrylics to imitate the finishes of oil paints without having to wait through the long drying times required by that medium.

Acrylic paints make it possible to create a rich and interesting variety of textures. Illustration by Montse Asensio.

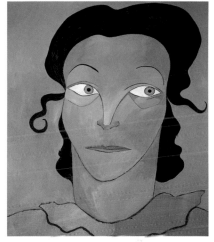

Acrylic paints cover well and don't change appearance once they are dry.

Acrylic paints give a drawing a very picturesque character. Illustration by Anthony Garner.

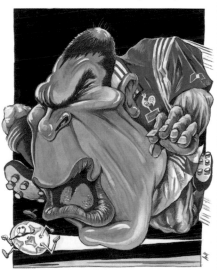

COMPOSING THE HUMAN FIGURE

In order to draw any distorted version of the human figure, it's essential to first become familiar with the normal human figure. The bodily proportions of each character, with respect to one another and to other people, are very important, and they have to be handled with great accuracy.

Study of Proportions

The purpose of studying the proportions of the human body is to develop a guideline that can be used to establish the various measurements. A drawing is said to be out of proportion when the head appears larger than normal, or the arms are too long or very short—in other words, when the figure depicted departs from perceived norms.

The present manner of representing the human figure descends from Greco-Latin culture. Ever since the era of Vitruvius, the measurements of the human body have been considered to be multiples and submultiples of the head. The rule that establishes the proportions of the human figure is based on a basic segmentation known as a module, which corresponds exactly to the measurements of the head. The classical canon determines that the total height of the body should be equal to eight heads, a measurement

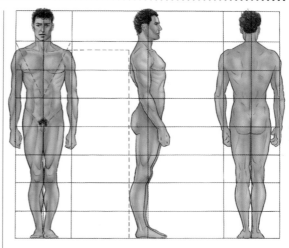

Frontal, side, and rear view of the canon of eight heads.

that has persisted to our time. The main usefulness of the canon based on modules is that it makes it possible to compare the relationship among the limbs based on references, the divisions between the modules, that remain constant, regardless of the real figure's stature.

Realistic Understanding

Before undertaking humorous distortion, it's a good idea to do a quick review of realistic drawing to establish some initial basic canons. In drawing a model, it's necessary to pay special attention to the bodily proportions. You

A drawing of a figure in caricature must be based on the classical canons, a more realistic and proportional view.

Based on a figurative representation of the human figure, the body can be reduced to a skeleton or a basic sketch.

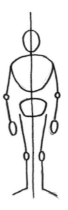

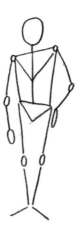

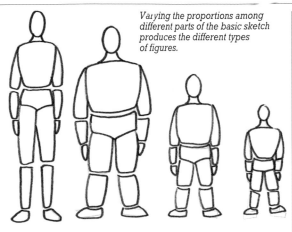

Varying the proportions among different parts of the basic sketch produces the different types of figures.

so that the relationships among the proportions in the human body can be exaggerated. This knowledge will allow us to draw any posture and movement; for that purpose, we have to know how the bones and muscles work.

Anatomy must allow us to differentiate the body of a corpulent or muscular person from a slender or scrawny one. On the basis of this elementary knowledge, every artist will be able to develop a personal, characteristic style by distorting, exaggerating, reducing, or increasing the established anatomical canons, and paying special attention to cohesiveness as the primary and fundamental rule.

must try to preserve the correct workings of the joints, study the arrangement of the bones and muscles, and check the size of the body masses and the way in which they relate to one another as a function of gravity in different poses.

Anatomy Is Essential

It is crucial to possess a basic understanding of anatomy

A Sketch of the Human Body

In order to draw the human body you must begin by establishing the schematic arrangement of the skeleton. A vertical line will do for the spinal column, and two horizontal lines can signal the height of the shoulders and the waist, which we can represent with two ovals. We then reduce the human figure to its essential parts: head, torso, and limbs. However, in order to ensure accuracy in the shape, the torso is divided into two parts: the thorax and the abdomen. The drawing is completed by adding to the extremities the lines that correspond to the arms and legs. The result is a simple figure based on three ovals and a few straight lines where the articulation points of the limbs are indicated, as with a wire doll.

"The Plan"

The *plan* or *skeleton* is the structure that is used as the basis for the figures that we are drawing. Starting with this schema, we can fill in the body using ovals and circles that create volume. This will then be the basis of the figure, and as a result, the figure's movement depends on that initial sketch.

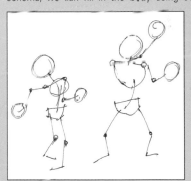

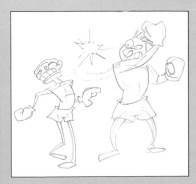

Based on the skeleton, it's easy to complete the characteristic features of the characters that figure in the illustration.

RULES FOR PHYSICAL DISTORTION

Once we have become familiar with the human body, we can experiment with distorting bodies. Our distortion, based on three circles or ovals, involves making the bodies larger or smaller, or flattening them to create the desired types.

Distortion with Ovals

With this type of treatment, the essential human shapes are reduced to a series of ovals. These basic ovals serve as a starting point in studying humorous deformation. We can start with something as simple as changing the relationship of sizes and proportions among different ovals, and in the same way we can stretch out or shorten the limbs in relation to the dimensions of the body. As we shall see, the primary system of distortion is based mainly on increasing or reducing the ovals, which are kept to correct proportions in a realistic drawing of the human figure.

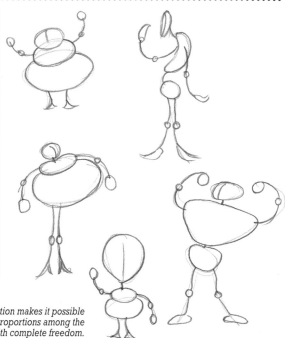

The principle of humorous distortion makes it possible to change the relationship of proportions among the ovals of the body with complete freedom.

Rotating the Character

The figures are not always presented in a frontal view; as a result, we have to learn to draw them from all possible angles. For that purpose we rotate the character, drawing it from the front, then from a three-quarter view, and then from the back. It is a help to use the schematic basis that produces the body based on ovals. In order to illustrate the point, we will start with a static pose and rotate it to different positions.

Rotating a figure makes it possible to study it from all possible viewpoints.
Illustration by Sergi Camara.

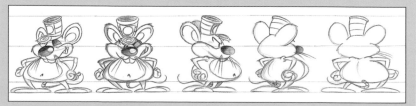

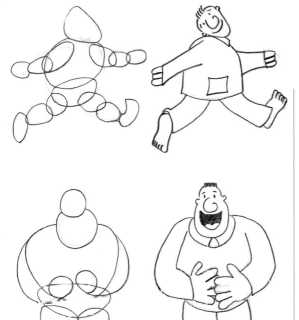

Distortion based on ovals makes it possible to develop different types and characters.

to create the distinctive distortions of each type to be represented. The limbs of the human body must be distorted in a consistent manner, never in isolation; the overall appearance of the figure has to be taken into account as a function of the person's character and personality, and the action being performed.

MORE ON THIS TOPIC
- Composing the Human Figure **p. 42**
- Basic Factors in Humorous Representation **p. 46**
- The Ages of a Human **p. 56**

Types and Characters

Every distortion is intended to represent a certain human type. Every character has a particular physical and psychological makeup that we wish to highlight. The humorous drawing will accentuate the special features of each of these types, whether they are athletic, fat, skinny, pudgy, short-legged, and so forth. In representing each of these types, we start with a preliminary sketch comprised of ovals in order to reduce, stretch out, lengthen, round, or otherwise deform the thoracic and abdominal ovals

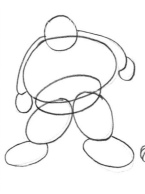

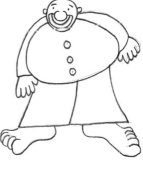

Using combinations of simple geometrical forms is the basis for drawing our characters.

BASIC FACTORS IN HUMOROUS REPRESENTATION

Today few illustrators use naturalistic representation in humorous drawing. The distortion of the models is the general tendency that helps highlight the comic effect or caricaturize the person portrayed.

The Psychology of the Characters

Humorous distortion accentuates not only the physical features of a given character, but also the psychological characteristics. Therefore, the humor artist has to determine if the person is vivacious, active, depressed, extroverted, timid, sentimental, quick-tempered, and so forth. In a good humorous drawing, it's not enough to represent the physical appearance; rather, it's important to keep in mind the classifications that can be established based on the individual's temperament and character, which are represented in specific physical types.

Formal hyperbole or exaggeration for the purpose of contrast is one of the most common resources for creating a comical situation. Illustration by Anthony Garner.

Choosing the Type

Once the character's psychological profile has been selected, we have to figure out how to represent it. We have to relate it to a specific physique. Nearly all temperaments and characters can be synthesized into four general types: thin, fat, corpulent, and normal (and in the female category we have to add the "exuberant" type). A thin physique can be used to represent nervous, calculating, cruel, devious, and sinister individuals (among others). An obese figure can be used to represent opulent, rich, kindhearted, gluttonous, slow-moving, and tedious people.

Incongruence is one of the basic elements in humorous drawing. Illustration by Anthony Garner.

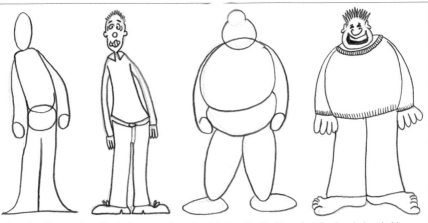

Once the character's outline is drawn, we have to relate to a standard type, keeping in mind such things as the fact that a nervous person is most likely to be slender, while a good-natured person is commonly represented as more plump. Illustrations by Montse Asensio.

An athletic body is ideally suited to heroes, young men, and brawny characters. Finally, a normal body can be used to represent a character who lives a life of moderation free from extravagances.

Exaggeration and Contrast

When we have decided on the basic features, there are still other factors we have to consider in putting together the character; they will help us in highlighting the humorous factor in our caricatures, and they include exaggeration, incongruence, and contrast. Hyperbole involves visual or verbal exaggeration, and it is therefore probably the most commonly used rhetorical resource in caricature. The distortion of sizes and shapes must serve to emphasize the individual characteristics of each subject (large heads, ridiculous bodies, exaggerated mouths, protruding eyes, etc.), and this applies to animals as well as to people. The contrast contributes to the comical situation. It results when a drawing presents a massive confrontation between opposites (e.g., monsters face to face with beauty, joy in the presence of sadness). For example, a huge sumo wrestler confronting a scrawny character is a situation involving clear visual contrast that easily produces a comical effect.

A Good Observer

A humor illustrator has to develop powers of observation by trying to caricaturize real models. All you have to do is sit in a park or the waiting room of a railroad station and try to capture the psychology and the temperament of an individual as expressed in facial features, pick up on the defining details, the character, and so forth. It's best to take along a note pad and fill it with different sketches that study the physiology of the real subject; then we can select at leisure the one we find most witty and attractive.

A sketch pad is a useful tool for jotting down ideas that can later be used in drawings.

ARMS AND LEGS

With the same system of ovals used up to this point, the areas that correspond to the arms and legs can be sketched using simple forms that can be distorted according to the character's needs and to determine the most appropriate humorous characterization.

Drawing the Arm

Drawing arms and legs may involve some problems with proportions, so a few comments are in order. It's possible to distinguish three clearly delineated areas: the shoulder, the upper arm (which is sizeable because of the biceps), and the forearm (comprised of a rather elongated oval). In the preliminary sketch the three areas can be represented by three ovals of different size according to whether the arms are strong and muscular or thin and weak. The ovals for weak arms are narrow and slightly broader at the elbow joint; athletic arms, on the other hand, are very bulky. Skinny arms are almost devoid of muscular shape, and fat people appear to have short, thick arms.

The Lower Extremities

The muscles of the lower extremities have a more complex shape, but a detailed analysis shows how each of them can likewise be identified. The most important factor involves remembering that the knee is not located in the middle of the leg length, measured from the groin to the ankle; this is a common error among inexperienced illustrators. The knee is actually located farther down, so the thigh has to be depicted as longer than the lower leg. The calf muscles protrude in the lower leg; they start just behind the knee and end in the Achilles tendon. The voluminous, rounded shape of the calves is the defining feature of the lower leg.

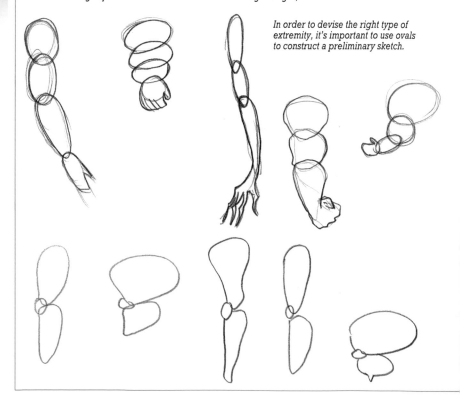

In order to devise the right type of extremity, it's important to use ovals to construct a preliminary sketch.

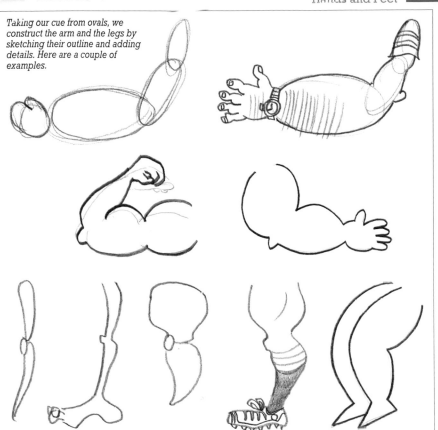

Taking our cue from ovals, we construct the arm and the legs by sketching their outline and adding details. Here are a couple of examples.

Women's Extremities

Women's arms are very different from those of men. The musculature is not as prominent, the proportions are more regular, and the outline is more delicate. In the legs, the shape of the muscles is scarcely visible. The thigh gradually becomes more slender as it approaches the knee, and the lines are smoother, without pronounced relief, so there is practically no emphasis on the circle formed by the knee. In the lower part of the leg, the slender calf muscles become more narrow as they approach the heel. In general, a woman's calf muscles are not prominent, although they do become rounder and more shapely if the model is wearing high-heeled shoes.

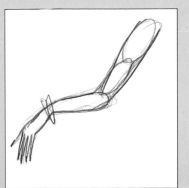

Female anatomy involves special considerations that need to be factored into humorous drawing.

HANDS AND FEET

One very important part of any humorous character is the hands and feet. When drawing them, we have to pay close attention to the details to achieve the greatest possible expression. That way we can convey all the character's actions with a variety of postures and movements.

The Hands

Hands can be nearly as expressive as faces. They are the part of the body that offers the greatest number of different positions.

When people are just starting out to draw human figures, the hands and feet are depicted poorly. Or they are left out and merely suggested by placing them in the pockets or hiding them behind the back. If you are capable of drawing expressive hands, you are already equipped with an important "arm" in your arsenal of humorous resources. Whenever we draw a hand of any type we need to express the metacarpus as a square module from which the fingers radiate outward.

The sketch can thus be completed by representing the fingers with three ovals, one for each digit. This is the secret to easily drawing a hand so that it will appear to be in perspective.

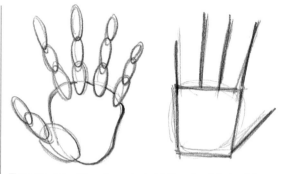

There are many different ways to sketch the palm of the hand; here are two examples.

The Feet

It is easier to draw the feet than the hands. This is because their movements are much more limited. The foot also translates into a more homogeneous and continuous shape.

The initial sketch will be done similarly to that of the hand: starting with a circle or oval that corresponds to the heel area, with another, longer oval for the metatarsus, and lines or small cylinders to represent the toes. The toes can be simplified quite a bit, especially when they are covered by shoes. In that case, you merely need to draw an elongated shape that's broader and bulkier in the front where the toes are located. A frontal view of the foot presents a few problems, though, because of the perspective of the toes; in this case they can simply be represented as circles.

Another example of how to construct the hand as shown by the illustrator Sergi Camara.

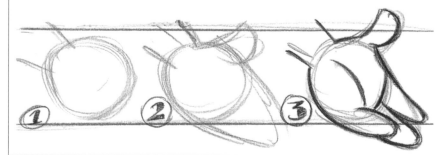

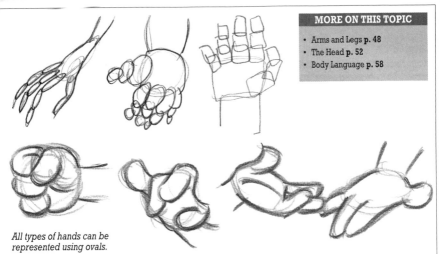

MORE ON THIS TOPIC

- Arms and Legs **p. 48**
- The Head **p. 52**
- Body Language **p. 58**

All types of hands can be represented using ovals.

Eliminating One Finger

It's common to reduce the number of a character's fingers to four, and not merely to make the illustrator's work easier. Leaving out one finger is part of the process of grotesque transformation that is typical of all characters who appear in comic strips.

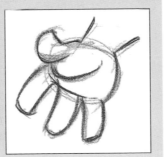

Four-fingered hands are very common in comic strips.

Sketches and Distortion

For both the hands and the feet, we initially draw a fairly round shape that allows us to include any necessary perspective. Next, we add the fingers and toes—whether five or any other appropriate number—for that is of no importance for expressiveness or movement. Then we add the distortion as a function of the physical or psychological types that we wish to represent, as we have already practiced with other parts of the body.

Ovals are also the point of departure in drawing the shape of the feet.

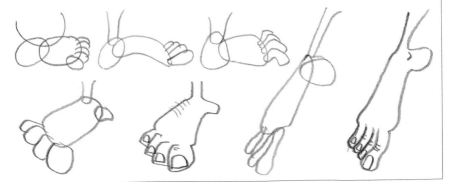

THE HEAD

The body as a whole is indicative of a character's general appearance, character, and attitude, but it is the head, and especially face, that constitutes the most expressive feature. This makes the head the most important part of the human body when representing any person. In this case, drawing the face requires not merely distortion but also the right combination of facial elements to create the desired expression.

Composing the Head

In order to draw the head, we begin with a simple ovoid shape for the cranial arch, which we then complete with a circle that defines the area of the jaw and chin. Using this sketch we can distort the figure based on the person we wish to depict. Every type of head relies on the proportions that are established between the oval of the skull and the jaw. A head with a large skull suggests a person with great intellectual capacity; a head with a protruding jaw represents a

In drawing the head we begin with two circles: the larger for the cranial arch and the smaller for the jaw.

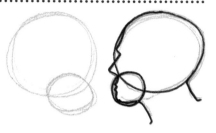

brawny person; and slender, pointed chin is the best choice for a sinister person. Our distortion, as in previous cases, consists of increasing, reducing,

flattening, lengthening, and so forth—in other words, subjecting the jaw to any feasible graphic treatment to create the desired image.

Disproportionate Size

Nowadays, heads in humorous drawings generally take on very exaggerated shapes. In the process of exaggerating the proportions of this part of the body, the head has come to occupy a quarter or more of the figure's total size, since this exaggeration allows for greater expressiveness. That is because the face is the most communicative feature of every person.

Characters in humorous drawings commonly have a very large head that is out of proportion with the rest of the body.

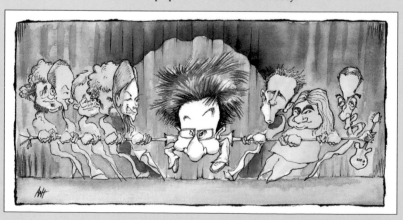

Drawing from the General to the Specific

In drawing the head, we should work from the general to the specific. In the first place, we have to draw a round shape and sketch the basic structure to create overall form and the most prominent angles. This ball or sphere needs to include some vertical and horizontal lines. The location of each feature is situated at the points where these lines intersect (nose, eyes, mouth, and so forth), and these are used to construct the character's head. If the intention is to create a caricature drawing, we have to keep in mind that scarcely any two eyes, noses, mouths, and ears are alike; trying to discover these differences in size and shape is the key to creating a likeness in a portrait.

MORE ON THIS TOPIC

- Rules for Physical Distortion **p. 44**
- The Ages of a Human **p. 56**

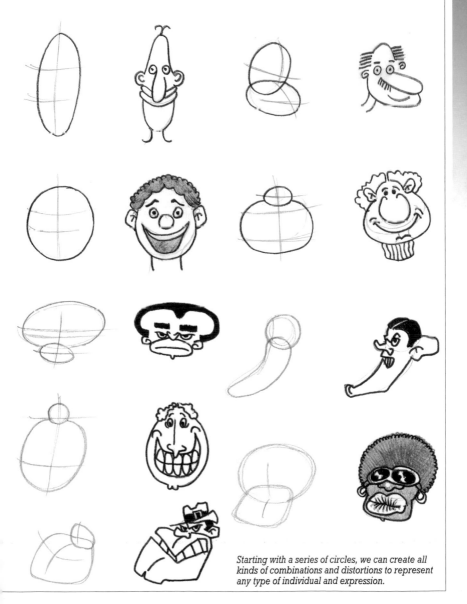

Starting with a series of circles, we can create all kinds of combinations and distortions to represent any type of individual and expression.

FACIAL EXPRESSION

We need to determine what precise changes make a face light up in a smile, look angry, or cloud over in an expression of sadness. Faces are a mirror of people's feelings, so we must learn to draw them if we hope to create expressive characters.

Studying Physiognomy

Any face that we draw, no matter how clumsy or childish it may appear, possesses an expression by the mere fact that it has been drawn. All possible expressions are created

MORE ON THIS TOPIC

- The Head **p. 52**
- Styles **p. 64**
- Sketches and Experimentation **p. 68**

through movement in the eyebrows, the eyes, the eyelids, and the mouth. As these features adapt different shapes and positions, the subject's expression instantly changes.

Astonishment, Delight, and Attention

Based on particular movements of the facial features, we can achieve a degree of exaggeration in facial attitudes that more intensely reinforces the

expressive effect. In order to do this, we have to be familiar with all types of human expressions.

When we are happy, for example, everything seems to expand, and this is visible in the face; the eyebrows arch upward and the mouth opens from ear to ear. On the other hand, in expressions of sadness, everything seems to go down: the eyebrows fall toward the sides, and the mouth, tiny and drooping, seems to be on the verge of losing control.

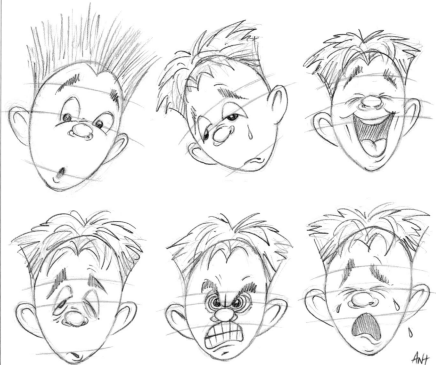

These facial expressions (surprise, sadness, happiness, fatigue, anger, and despair) are the product of the right combination of movements in the eyebrows, eyes, and mouth.

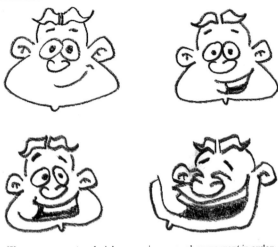

We can exaggerate a facial expression as much as we want in order to create the desired intensity.

Derived Expressions

Derived expressions are the ones that result from combining the basic expressions mentioned previously. The repertory expands in proportion to the various degrees of intensity that correspond to the various states of mind. Therefore, in the case of an angry expression, we can proceed from disgust to ire, and from there to rage; the same thing happens with happiness, since we can proceed from a simple smile to uncontrolled laughter. The only thing that varies is the greater or lesser emphasis placed on the features, which create every expression from the most subtle to the most obvious. In order to practice, we can draw a character's face in a neutral, normal expression and gradually intensify the expression until the shape becomes exaggerated.

In a facial expression that conveys anger, everything seems to contract and create tension rather than expansion: the eyebrows merge in the center of the face, and the mouth twists toward the chin.

Supporting Graphic Signals

In humorous drawing, there are other resources that help intensify expressions and give them a certain amount of emphasis. These resources are known as graphic signals; they are used in expressing both simple states of mind and great tension. The most common ones are straight lines, which express amazement or set off the character's face; broken or zigzag lines in the shape of lightning bolts, which express irritation; wavy, parallel lines, which represent fear, and droplets that seem to spring from the face, which represent both sweat and the tears of sadness or hearty laughter.

The supporting signals accompany a character's facial expression to draw attention to it and intensify it.

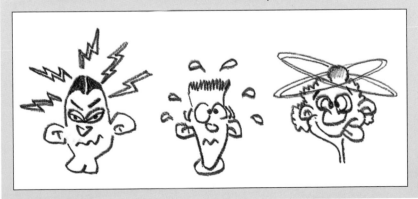

THE AGES OF A HUMAN

In large measure, the shape of the human body depends on its makeup. Therefore, if an artist hopes to draw the figure correctly, it is important to know how anatomy corresponds to the subject's age. An ability to synthesize is another essential ingredient in laying out the drawing of a person.

Babies

In infancy, anatomy is in a state of constant evolution, so the proportions change drastically in a few years. In babies, one basic feature is that the head is much larger with respect to the body than with adults. This characteristic becomes less pronounced as the body develops. When newborns enter the world, their heads are very large in relation to their arms and legs. In general babies have a height equivalent to just three times their head.

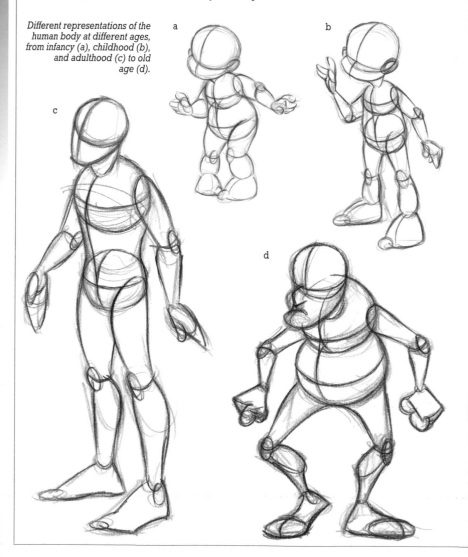

Different representations of the human body at different ages, from infancy (a), childhood (b), and adulthood (c) to old age (d).

Children

A child's legs are still relatively short in comparison to the head and the torso. At the age of four the head is still very large, but an increase in height means that now the figure is composed of five modules rather than four. The trunk is broader, and the chest lengthens with respect to the stomach, which previously had occupied most of the torso. At twelve years, the child's total height is equivalent to seven times the length of the head, and the midpoint of the body descends slightly to the level of the hips.

Adults

An adult's body has already developed the maximum extension of the limbs, and the torso and the muscles also exhibit greater volume. However, within this category, as we have seen above, there are many different body types based on physical appearance. This means that in humorous drawings adults belong to the age group that presents the greatest number of physical variations and disproportions related to the character's psychology, so it is harder to establish a prototype. A woman's musculature is practically identical to a man's. However, the female body has a more obvious layer of subcutaneous fat, which produces more softness and voluptuousness in the outward shapes.

Older People

An older person's body is clearly different from that of a younger adult. It is commonly slender and bent. The arms appear more scrawny and fragile, as do the legs, which scarcely can support the person's weight. Older people have lost a good part of their muscle mass, and as a result their body shape is defined much more by their bones. Also, when people grow old the skin tends to lose elasticity and shrink, which makes it appear that the bones are close to the surface. As long as old age is not accompanied by pronounced obesity, it is common for the fat to disappear and the skin to waste away, and as a result of all this, the shape of the body is strongly influenced by the skeleton.

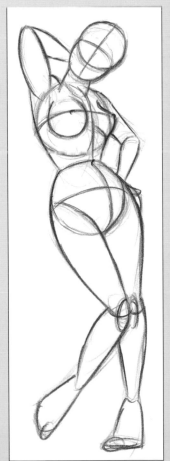

Sensuality and Eroticism

If we wish to draw a voluptuous, seductive, and attractive female body, we have to emphasize the roundness of the body to exaggerate the woman's anatomy. The arms and legs must maintain the proper relationship with the rest of the body, and the parts that carry sexual importance, such as the hips, the breasts, and the buttocks, have to be presented in a more suggestive and voluptuous shape.

Exaggerating shapes of the female body will result in figures with a clearly sensual content and a strong erotic message.

MORE ON THIS TOPIC

- Composing the Human Figure **p. 42**
- Rules for Physical Distortion **p. 44**
- Body Language **p. 58**

BODY LANGUAGE

To complete the study of humorous distortion, we will now analyze expression through body language. The force and attraction of characters is based on the way they relate to their surroundings, the postures they adopt, their gestures, and the facial expressions that they use as a type of nonverbal language.

Expressions and Gestures

In drawing, it's necessary to begin with a knowledge of realistic gestures and the body's mechanical abilities with respect to the arms and legs. The ways in which people move can put us onto the right track for our characters, including their occupation. Our movements are related to our emotions and thoughts. On that basis, the idea is to capture the posture or attitude of a known person, or of a stranger on the streets, and transpose it to the paper with a generous dose of exaggeration. There's no cause for alarm if the people we draw perform exaggerated, theatrical gestures. We must never forget that we are offering the spectator visual clues, not accurate representations of reality.

MORE ON THIS TOPIC

- Rules for Physical Distortion **p. 44**
- The Ags of a Human **p. 56**
- Action and Movement **p. 62**

Dress

It is possible to fill sheets with character studies that combine initial ideas and progressive character expressions by playing with clothing and facial expressions. It's important that the characters' attire be consistent with their surroundings, profession, age, social class, and so forth.

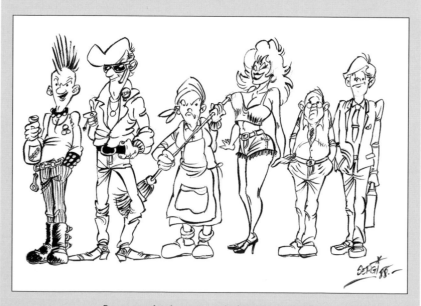

Dress says a lot about a person's character, profession, and tastes. Illustration by Sergi Camara.

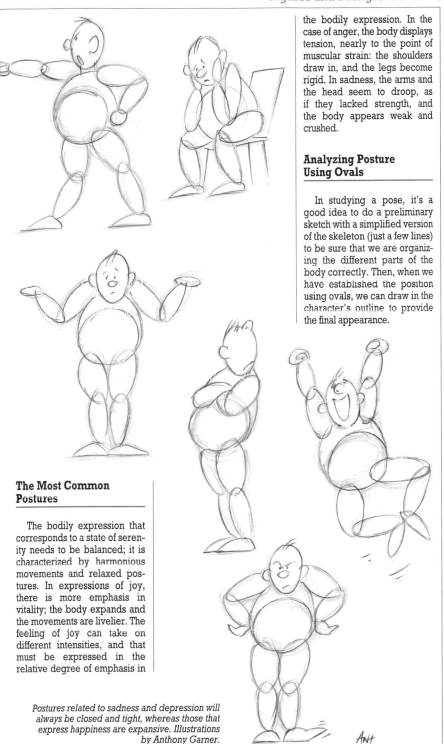

the bodily expression. In the case of anger, the body displays tension, nearly to the point of muscular strain: the shoulders draw in, and the legs become rigid. In sadness, the arms and the head seem to droop, as if they lacked strength, and the body appears weak and crushed.

Analyzing Posture Using Ovals

In studying a pose, it's a good idea to do a preliminary sketch with a simplified version of the skeleton (just a few lines) to be sure that we are organizing the different parts of the body correctly. Then, when we have established the position using ovals, we can draw in the character's outline to provide the final appearance.

The Most Common Postures

The bodily expression that corresponds to a state of serenity needs to be balanced; it is characterized by harmonious movements and relaxed postures. In expressions of joy, there is more emphasis in vitality; the body expands and the movements are livelier. The feeling of joy can take on different intensities, and that must be expressed in the relative degree of emphasis in

Postures related to sadness and depression will always be closed and tight, whereas those that express happiness are expansive. Illustrations by Anthony Garner.

FIGURES AND BACKGROUND

Many of the tricks used to create an illusion of depth and space are related to one type of perspective or another. But it's not enough merely to represent space in three dimensions; you have to do some research to properly convey the framework or surroundings in which the action takes place to transmit a sense of reality to the reader.

Space and Perspective

Perspective is essential in giving depth to humorous drawings. As a rule artists use conventional linear perspective to give their works the right amount of depth.

The farther away an object is, the smaller it must appear. The most obvious reduction in size is linear. It can be created clearly by referring to the conventions involving location and the vanishing point on the horizon—in other words, the point to which all the perspective lines point.

We mustn't forget that traditional perspective is a trick unto itself, a mere illusion, which we nonetheless accept unquestioningly, as if we were provided with a true representation of depth.

With perspective, the proportional size reduction of objects in the distance is evident. Illustration by Sergi Camara.

Backdrops

French artists adopted this scenographic term to designate a type of composition in which the overlaying of successive planes produces an illusion of depth or three-dimensionality.

The overlapping planes lighten in color as if they were superimposed bands of different shades. The differences in luminosity contribute to the impression of distance and, therefore, the effect of depth.

Aerial Perspective

There is also a perspective that uses no lines, vanishing points, or spatial divisions, but which also creates three-dimensionality.

When we look at a real scene, our perception is affected by the color values of the various elements. Atmospheric refraction produces changes that cause the most distant objects to seem blue or purple. The effect of depth and atmosphere is an optical illusion produced by water vapor and suspended dust particles in the air, which partially discolor and diffuse colors and shapes in the

The succession of planes similar to backdrops also serves to represent depth. Illustration by Anthony Garner.

Another technique used to suggest the effect of distance involves lightening the colors of the backdrop. The horizon should always appear more purplish and diffused than the foreground. Illustration by Montse Asensio.

distance. As a result, the focus is less clear than in the foreground; few details are perceptible, color contrasts are more subdued, and there is not much distinction between light and dark colors.

If we exaggerate aerial perspective, we can make the most distant planes appear to be incredibly far away.

Aerial perspective is a real attention-getter for the spectator; it allows creating very suggestive surroundings for our characters. Illustration by Sergi Camara.

Creating Atmosphere

In humorous drawing, atmosphere is just as crucial a narrative element as space. After creating the space, the setting and the atmosphere in which our character will be situated have to be developed: a medieval setting, a nighttime setting, a smoke-filled bar, etc. The right atmosphere is often as important as the characters themselves.

This scene takes place in a night setting in which artificial illumination produces a combination of interesting effects of light and shadow. Illustration by Sergi Camara.

TECHNIQUES AND PRACTICES

ACTION AND MOVEMENT

The right application of the effects of movement allows the illustrator to apply many variations to the natural behavior of objects and characters, whether by means of exaggeration, contrast, distortion, or dramatic emphasis on reality.

Exaggeration of Form

Movement produces a certain impression of elasticity in the figure, an irregular distortion, a loss and regain of balance, and a certain effect of shock or impact. We will use distortion to highlight the seriousness of a fall, the impact of a blow or a shock, or a quick twist of the body. This involves the physical deformation of certain features of the characters to emphasize the dynamic effect of the action, and stress the shape of the features that give meaning to the movement. In sum, this involves exaggerating the movements to give the action drawings greater expressiveness.

The Line of Action or Force

In order for a figure to give the impression of movement an internal line has to play a role; this is an imaginary line that is drawn through the figure to indicate the effect of

In depicting this dancing character the effect of the motion has been emphasized through formal distortion. Illustration by Anthony Garner.

mobility. This structural line, which we call the line of action or line of force, should be the starting point of any drawing involving motion. Working with lines of force allows us to address the entire movement of the figure; there's no point in drawing an arm poised to deliver a punch if the other features are not positioned along with that arm in a cohesive manner.

Graphic Resources

There is a whole range of graphic resources based on curved, wavy, or straight lines that help indicate the direction of the movement. They are used to support the expressiveness of the action by indicating trajectory, direction, and variants and characteristics. These lines are also commonly used to indicate certain qualities of the action represented, such as shivering, speed, impact . . . These are very important resources

The line of action is an imaginary line that runs through the figure to illustrate the body's rhythm and motion.

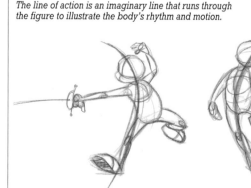

in depicting the intensity and the characteristics of the movement.

Kinetic Lines

Kinetic lines may be one of the most familiar and commonly used graphic resources among comics illustrators. These are visual conventions that suggest movement or the trajectory of objects in motion. Straight or curved lines indicate the space or the direction of the figure as it moves. These lines need to be clean, continuous and cohesive, with no breaks or interruptions, and may be accompanied by other graphic signs. In a similar vein, any traces that characters

Simultaneity of Action

The dynamic qualities of reality can be represented by conveying movement through successive images. In other words, by giving the figure different positions in a plane to represent an action. This involves suggesting the character's action by drawing the person with more than one superimposed arm or leg.

Simultaneity of action makes it possible to see the figure's limbs in motion.

leave as they move are effective; these include such things as the dust they stir up.

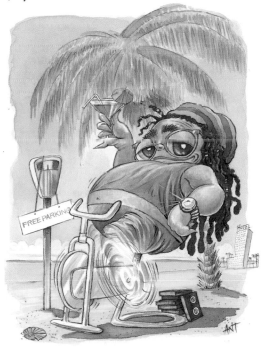

MORE ON THIS TOPIC
• Body Language **p. 58**
• Character Development **p. 70**

In this drawing the person's pedaling speed makes it possible to represent the legs by a little "cyclone" or rotary effect. Illustration by Anthony Garner.

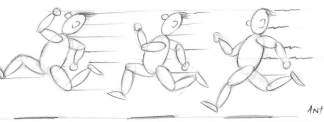

Kinetic lines supply information about the runner's speed.

STYLES

There are two modalities or tendencies in humorous drawing. The way in which artists give expression to their style depends on the technique of the illustration, the application of color, the ground, the type of line or brushstroke used, and especially on the graphic and humorous intention of the work. This chapter will deal with the most representative styles.

Types of Distortion

Every drawing requires some deformation as part of the desired humorous style and intention. The following sections will describe the three major tendencies that give rise to many other styles. Many satirical illustrators are capable of varying the type of illustration depending on the requirements of the technique best suited to the project.

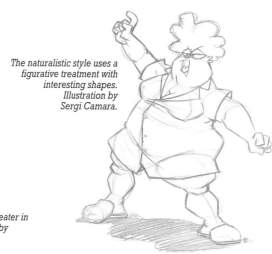

The naturalistic style uses a figurative treatment with interesting shapes. Illustration by Sergi Camara.

The degree of distortion is much greater in the psychological style. Illustration by Anthony Garner.

The decorative style especially seeks physical, artistic effects. Illustration by Montse Asensio.

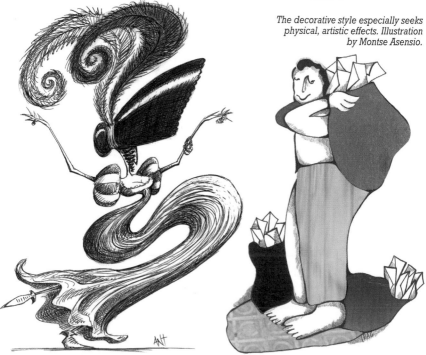

Naturalistic Style

Humorous drawings included in this style are ones in which the line maintains clear contact with realistic representation. In these illustrations, the degree of distortion is small and carefully considered, and the characters are held to coherent proportions. The treatment of the figures commonly is quite volumetric, observing the interplay of light and shadow, in addition to demonstrating a clear interest in the textures of materials. Drawings of this type are generally used in narrative illustrations and humorous works that criticize current events.

In a decorative drawing, physical effects appear carefully controlled. Illustration by Anthony Garner.

Psychological Style

Distortion reaches the highest degree in the style known as psychological, producing a greater distance from realistic canons in favor of synthesis and abstraction. The size of the head, the shape of the body, and the arrangement of the facial features take on incongruous characteristics. This is a type of ingenious and creative humor that seeks to create a more intellectual effect on the reader.

Decorative Style

This involves a distortion that seeks purely esthetic purposes, in other words, in which everything is subordinated to producing certain physical effects. This is a type of drawing that is intimately connected to the overall design of every publication and is commonly a technical complement. This usually involves marginal illustrations that enrich the graphic design of the page. Advertising art and works intended for children's publications can also be included in this category.

Conceptual Drawing

Conceptual drawing is essentially creative and free. Much of its success comes from the illustrator's stylistic originality. A conceptual drawing presents general ideas, not specific facts. Conceptual images must be graphically bold and have a great visual impact.

Conceptual drawings base their success on visual impact, more on the message than on the quality.

STYLE AND CREATIVITY

In order to develop a creative work, whether or not it's realistic in nature, it's essential to have a good mastery of drawing technique and know how to express a personal style. Our style must reflect our personality and adapt to our critical vision of things.

The Search for a Personal Style

Every professional has a characteristic style that evolves over time and is more controlled than spontaneous, and which must always reflect clearly and effectively the general concept or the theme of the illustration.

Many graphic humorists have a personal style that's very close to caricature and are capable of creating a situation involving one or more characters through simple indications that convey the most specific forms, with no ancillary details. These works are deceptively simple: in fact, they require great mastery of stroke, shape, and movement of the human figure, and lots of previous experience in characterizing people, who must be immediately recognizable to the reader.

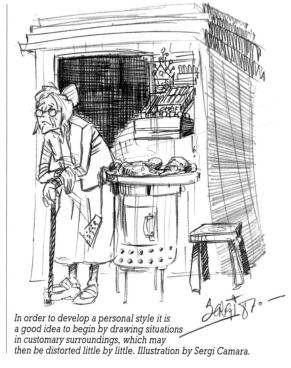

In order to develop a personal style it is a good idea to begin by drawing situations in customary surroundings, which may then be distorted little by little. Illustration by Sergi Camara.

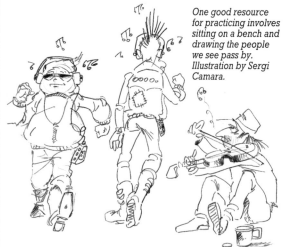

One good resource for practicing involves sitting on a bench and drawing the people we see pass by. Illustration by Sergi Camara.

Stylistic Variety

The different types of humorous drawings require different styles. Comic book illustrations and graphic humor are based on an uninhibited and personal style. This is true for children's illustrations, too; in them there is no substitute for the illustrator's spontaneous flair. In general, painted illustrations need a somewhat more simplified drawing than ones in which line and color are the only technical resources; in the former, an outline drawing that defines the shape and leaves room for the color may be sufficient. Professional illustrators are able to

Practice and experimentation help us to find the best style for representing any person. Sketches by Anthony Garner.

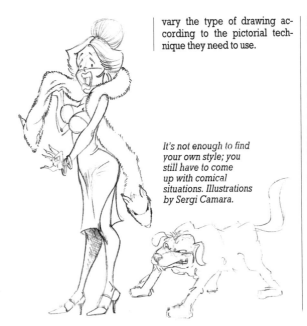

vary the type of drawing according to the pictorial technique they need to use.

It's not enough to find your own style; you still have to come up with comical situations. Illustrations by Sergi Camara.

Looking for Comical Situations

When we do a humorous drawing, we cannot think only about developing a personal style and about the right application of technique, in other words about the methods, systems, and resources that help us produce high-quality works. It's also necessary for the drawing to have a humorous intent. We produce a humorous effect when the situation provides an unexpected or inappropriate outcome, accompanied by a certain exaggeration or distortion of the general circumstances or the protagonists. Then we increase the comic elements of the formal situation of the characters and a convincing staging of the scene.

Representing Objects

Humor illustrators also have to distort and stylize objects, giving them a specific personality that includes comic effects in harmony with the rest of the characters and elements that make

up the scene. Once again, we can use a preliminary sketch to provide a basis for developing the final drawing.

Even objects have to be caricaturized in a stereotyped fashion so that they fit in with the figures. Illustration by Sergi Camara.

SKETCHES AND EXPERIMENTATION

Every humorous drawing requires previous experimentation for studying the character, the composition, and the end result. During these preliminary experiments, it is good to check your ability to draw continuous lines without lifting the pencil from the paper, and train the movements of your hand along with the spontaneity of the sketches to emphasize and establish the features.

Experimental Doodling

Doodles are lines drawn in a nervous and casual manner. These pictures are often drawn with total liberty and can cover the range from abstract models to crude, grotesque drawings. In this type of free drawing, the lines can be of any type. This involves lines that the artist produces naturally by way of reflexive training, in an intuitive way, practically without thinking. The result may be very elaborate drawings or ones comprised of wandering or hesitant lines. It's a drawing that is a translation onto paper of physical gestures performed quickly and spontaneously.

Doodling is a search process that studies the human situations that we commonly encounter in our surroundings. Sketches by Anthony Garner.

This way of drawing is a good method for breaking into humorous drawing and practicing without fear of going wrong. As a result, it's a good idea to take several blank sheets and fill them with doodles that serve as quick sketches that attempt to determine the character's main anatomical and physiognomic traits.

Continuous Lines

In a humorous drawing, the spontaneity comes from the active movements of the artist's arm or wrist, and the theme is communicated using rhythmic lines. The best way to encourage agility and liveliness in drawing is to make use of practice sketches, in other words, the sketches you use to learn and improve or pro-

A technical pen can also be used to experiment with doodling, in this case for practicing drawing long, uninterrupted lines.

ject yourself into a situation before starting to work. If we have been experimenting with sketches, we can affirm the features of the resulting doodles by using long, continuous, clean lines with no retouching or corrections. The thickness and weight of the line, its fluidity, and its experimental character, the way in which it continues or is interrupted, are a few of the devices used to create effective visual illusions. If the artist wishes, the drawing can also be done in color, using a blue or red pencil to sketch the figure and another one with black graphite for a more definitive drawing.

The Finished Drawing

If we carry the humorous drawing to its highest level, depicting all the shapes and details, our product is a finished humorous work. This type of treatment is related to the naturalistic style that was described earlier. In a detailed drawing of the elements that make up the models, reflections and textures cease to be strictly realistic effects and are incorporated into the work as simple graphic signs remotely resembling reality. In other words, the details are sketched

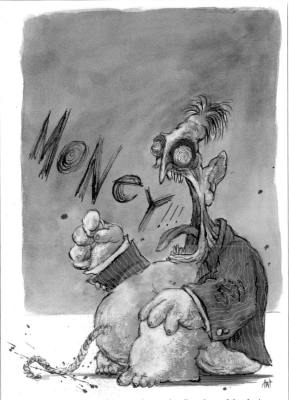

Elaborate drawings require attention to detail and careful coloring that clarifies the shapes. Illustration by Anthony Garner.

in such a way that they are no longer important in the process of distorting the figure, and are

transformed into very simple symbols of whatever it is they represent.

Technical Pens

Of all the drawing tools, the technical pen is the most modern. It works practically like a fine-tip marker, except that technical pens are manufactured in very precise sizes that produce a line of nearly constant width. They are commonly used for doing spontaneous and casual drawings, developing doodles of people, or simply to experiment with crosshatching.

Technical pens are very useful tools for inking; they produce dark lines of uniform width.

CHARACTER DEVELOPMENT

Once we have studied the component parts involved in distortion, we need to begin to caricaturize known models or to design characters, giving them a particular mobility, expression, wardrobe, and additional features. We can discover a character's expressive possibilities through a development process involving different sketches.

Different Visions

If we wish to develop characters to be the protagonists of our humorous comic strips, we will need to know all the possibilities the characters may offer. One good way to delve into the study involves filling a page with different views of the chosen characters to help us get an idea of their physical makeup and gestures. It's important to draw them in different attitudes and actions that reveal both their character and their most common postures. Finally, we can finish up with a few approximations of the faces to study the expressive possibilities they offer. Then, once the characters' anatomy has been constructed using the oval system, we can dress them without affecting their initial proportions. It's important that our characters dress in a manner consistent with their temperament.

MORE ON THIS TOPIC

- Basic Factors in Humorous Representation **p. 46**
- Facial Expression **p. 54**

It's important to draw the character from several viewpoints using different postures and facial expressions.

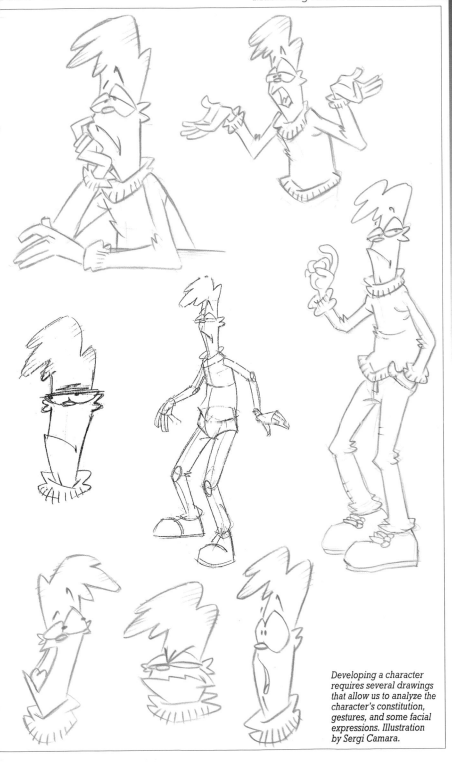

Developing a character requires several drawings that allow us to analyze the character's constitution, gestures, and some facial expressions. Illustration by Sergi Camara.

MASTERING LINE: PEN AND INK

As we have already explained, ink as a drawing medium allows many different treatments according to the instrument used to apply it. A nib is the most common one, but you can also draw with a reed pen, a brush, or conventional writing pens. Depending on the method selected, the results can vary from the most meticulous and detailed to the most spontaneous done in colors, washes, graphics, and more.

A drawing can be shaded with crosshatched lines; outlining is done using continuous lines that vary in width depending on the pressure exerted.

Pen Drawings

Pen is a generic term that we use to designate several implements, including nibs, reeds, and technical pens. Expert illustrators can use these instruments without having to do a preliminary pencil sketch; at the most, they use a pencil to lay out the basic lines of the work. Almost all the mediums mentioned are very responsive to the pressure exerted on them and vary the width of line; this kind of line has an incomparable vitality that can't be duplicated with any other medium. And all the possibili-ties offered by the pen are further expanded through the application of watercolors, whether used full strength or diluted. A line drawing done in ink is appropriate for all styles; nevertheless, it's best used in works with a naturalistic tendency. In the naturalistic style, pens offer the best possibilities for detail in drawing folds, wrinkles, and the texture of hair.

Technical pens are ideal for making sketches and find their broadest application in a schematic and symbolic style, even though they are not as versatile and elegant as the metallic nib. Their line, which is intense and attractive, nevertheless offers few expressive resources; the width is uniform and there are not many possible variations.

Lines Drawn with Nibs

Nibs allow a fine, clean line; they can be used for inking any drawing and then adding shading that gives depth to the shapes. When you need to use different grays with the same ink, using no wash, the solution is to combine the line with the white of the paper; every

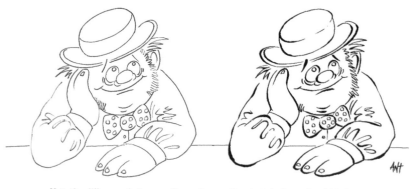

Note the difference between a figure drawn with a technical pen, in which the line is uniform, and another version done with a metal nib, which allows varying the value of the line. Illustrations by Anthony Garner.

Pen and ink are the most common techniques in the comics field. Illustration by Sergi Camara.

type of line, depending on its proximity and shape, makes it possible to produce planes of grays and different shapes. The textures that can be created in shadows range from opaque black to transparent veils made up of crosshatched lines. It takes lots of practice to master the many possibilities that these work tools offer. A simple drawing is all that is needed for working with a good number of grays; all you have to do is follow the direction of the plane of each of the objects in the model.

Comics

In the realm of humorous drawing, comics can be considered a world apart. This is a genre practiced by highly specialized illustrators, and which requires a very special narrative talent in addition to skills in graphics. Comics

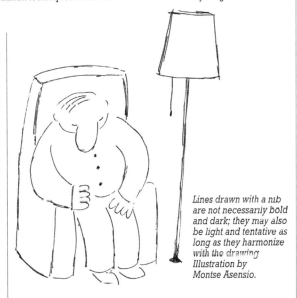

Lines drawn with a nib are not necessarily bold and dark; they may also be light and tentative as long as they harmonize with the drawing Illustration by Montse Asensio.

illustrators have to be able to interpret a script and lay it out in a way similar to cinematographic technique, in addition

to creating well-rounded characters. Their work doesn't involve illustrating books, but creating them entirely.

Erasing with a Razor Blade

A razor blade is an essential tool for correcting inking errors. It's also very useful for freeing up open areas and toning down brightness. In this example we can see the illustrator scratching off a small bit of pen line that had slipped beyond the outline of the figure.

Scraping the drawing with a razor blade removes mistakes.

LINES MADE WITH A BRUSH

In humorous ink drawings, an artist's brush is one of the most versatile utensils, but it is also the one that requires the greatest amount of dexterity. Brush drawings are rich in different types of lines and have a good deal of dynamism. Brushes are especially well suited to drawings where they contribute a particular interest to both the value of the line and the effects of light and shadow.

The lighter we make the ink wash, the more it spreads out and diffuses.

An artist's brush produces a dark line of variable width depending on the pressure exerted on it.

Line Quality

The tip of a flexible brush is one of the drawing media that produces the most suggestive and expressive lines. The range of different lines that it offers keeps the work from ever appearing mechanical. The artist's brush is really a very flexible drawing medium and is more manageable than a nib, since it can be moved with great speed and fluidity. A brush makes it easy to change directions, rounding and turning corners where a pen or a pencil would have

difficulty. A round brush with a good tuft of sable bristles can deliver line, rhythm, and shape in a single stroke.

In brush drawing, it's common to use no more than two colors. The variations in shading obtained by controlling the amount of water mixed with the colors make up for this limitation.

Filling in Black

In addition to a purely linear use, brushes can also

The brush is used to fill in areas with black and to provide contrast in ink drawings.

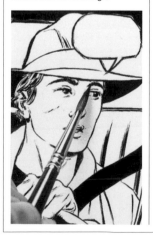

Block Style

This drawing technique uses only areas of black, dispensing entirely with intermediate shades and grays. A pencil drawing is required as a starting point for the block style; it must set up clearly the two contrasting areas without losing the sense of the shapes. These drawings are done using a pen for fine lines and a brush for the larger areas of color.

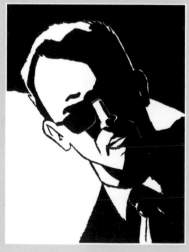

The block style uses no intermediate tones. It is based on strong contrasts between the paper and the black ink.

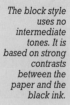

Once the drawing is finished, tonal values can be added using a brush. Illustration by Sergi Camara.

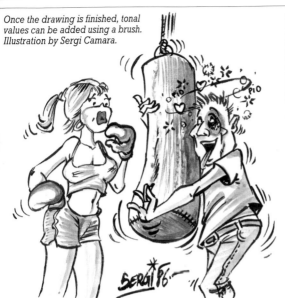

Varied Line Weights

In ink drawings, it's common to vary the weight of the line to create greater graphic expressiveness.

It's possible to create two basic types of lines: the first is rather thick and dark and is applied to the outer contour or silhouette, or to indicate folds or important shapes inside a figure; the second is created from finer lines placed close together that are often used inside a figure to define details, secondary features, and textures. As in working with a metal nib, these lines can be applied in the form of crosshatching.

create a more tonal appearance. This is commonly used to fill in areas in pen drawings with black, since filling in those areas with the pen would be slow and laborious. Using the brush directly without diluting the ink is an economical way to create strong effects of light and shadow, so that the illuminated areas of the figure stand out from a dark outline, as if they were in a spotlight.

Frottage

Frottage, or dry brush technique, involves painting with a brush saturated with color but with little water so that the scrubbing action reproduces the rough texture of the paper. The *frottage* technique is suited to creating contrasts, representing the rough and uneven texture of certain objects, and it's also ideal for creating intermediate shades.

If we scrub the tip of the dry brush on the paper, we create small textured spots that have great graphic effect. Illustration by Anthony Garner.

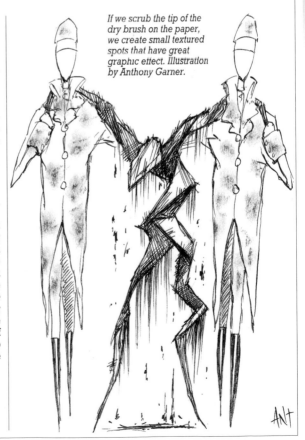

LIGHTING

The effects of light and their consistent application are important elements in creating a given atmosphere in our drawings. Similarly, the way in which light strikes a figure can influence the way the character's personality and expression are perceived. You can enhance the visual and emotional impact of the work if you know how to make good use of lighting.

Shadows on Objects

Light almost always comes from a single source. The location of this source with respect to the various elements of the work determines such things as how the shadows fall and how facial features are illuminated. The way in which light strikes a face can have an influence on how personality and expression are perceived. When the light comes from above, it highlights the shadows

a b

c d

Here is a sample of how shadows function, comparing the same character illuminated from different directions: with the light source coming from the left (a), form the right (b), from below (c), and from above (d).

Combining Line and Color

The technique of combining line and color is the most complete one, and it offers great possibilities in humorous drawing. It involves applying watercolor washes to a drawing done with lines. Including areas of watercolor always provides a rich expressiveness and nuances that works done only with lines don't have.

Combining line and color in a single work makes the drawing more complete. Illustration by Montse Asensio.

Luminous effects can present very striking finishes, especially in the case of backlighting. Illustration by Anthony Garner.

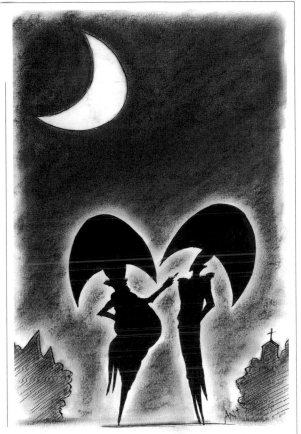

around the eyes and gives them a sinister look; from the side, it outlines the features and highlights the character. Two simultaneous light sources give the face a more sensitive look, and an illuminated edge can be used to create a dramatic effect. We can also use unreal light effects to create dramatic scenes with great impact.

Silhouettes

An object lighted entirely from behind looks like a completely flat shape. Therefore, if this type of illumination is desired, the silhouetted object needs to have an interesting outline. Silhouettes can have a dramatic impact when emphasizing certain elements more than others.

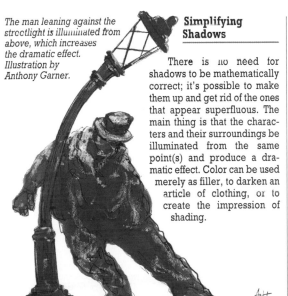

The man leaning against the streetlight is illuminated from above, which increases the dramatic effect. Illustration by Anthony Garner.

Simplifying Shadows

There is no need for shadows to be mathematically correct; it's possible to make them up and get rid of the ones that appear superfluous. The main thing is that the characters and their surroundings be illuminated from the same point(s) and produce a dramatic effect. Color can be used merely as filler, to darken an article of clothing, or to create the impression of shading.

Shading with Color

Humorous drawings done using only colored areas are not very common. The ones that exist are nearly all done with watercolor washes and ink of a single color or in gouache. Gouache is not particularly well suited to shading; therefore flat areas of color are used on sketches done in advance in pencil, and then the lines and outlines are drawn in. The color nuances provided by watercolors are used for works that are clearly based on classical drawing. They are used to emphasize shapes by means of appropriate shading.

TECHNIQUES AND PRACTICES

CONCERNING ILLUSTRATION

Humorous drawing applied to illustration is a very broad field. Periodicals use it to illustrate articles and reports, mastheads, titles, title pages, and even entire pages. All you have to do is glance at the most widely circulated illustrated magazines in the marketplace to see the tremendous variety of styles and techniques that are currently in use.

Variety of Styles

The styles that we can find in humorous drawing used in illustration can be extremely varied, and this variety depends in large measure on the text illustrated and the editorial policy of the publication. For example, in children's publications a decorative style will predominate, characterized by simplicity of line and expression. There are many types of children's books, from the most simple stories intended for young children to more complex narratives that in no way take a backseat to literature for adults. On the other hand, there is a more pronounced distortion in publications for adults, which is determined by the psychological style. The

Humorous illustration presents a great number of styles, nearly always determined by the originality of the design. Illustration by Montse Asensio.

abstraction process reaches its highest plane in literary works and articles by certain authors.

Cartoons

Cartoons are undoubtedly the most popular humorous vignettes in newspapers. They are no more than graphic snapshots, an abstract and fleeting representation of aspects of daily life in which one or more people in various circumstances carry out an action that results in a comical situation. Prominent within this genre are satirical cartoons, that is, the ones that censure certain institutions and political ideas, customs, social attitudes, and even the performance of certain public figures. The secret of a good cartoon is its ability to be understood quickly and easily.

Commercial Illustration

Commercial illustration is designed to accompany or to give shape and personality to a commercial brand or product, or else to announce an event. Many times, what distinguishes

Cartoons are among the most common illustrations in newspapers. Illustration by Sergi Camara.

Poster Art

Creating posters has a lot in common with book title pages (as we have already pointed out, oftentimes title pages are adapted for advertising purposes), but they require even more graphic brilliance, since they have to compete with many other visual ads. Nowadays there are not many posters that rely on humorous drawing, since photography and modern illustration techniques on the computer have taken over this field, which traditionally had been the realm of painters and illustrators.

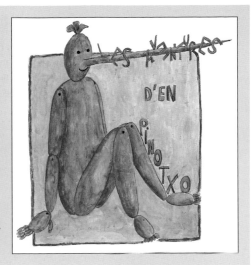

Humorous drawing is one option available to illustrators in producing posters and book covers. Illustration by Montse Asensio.

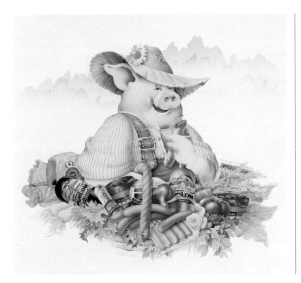

it from the rest of the illustrations is a mere question of format. For example, most publishing houses adapt and enlarge the designs on the title pages of their books to be used as promotional posters. In any case, the essential feature of commercial illustration is its immediate and effective visual impact. Humorous drawing that is decorative, stylized, and perfectly suited to producing the impact of the ad is an interesting field within this specialty.

Commercial illustration incorporates the product line of the advertised brand, and at the same time it creates an appropriate and attractive image from a commercial standpoint.

The success of a good cartoon relies not so much on the execution of the drawing as on the cleverness of the image. Illustration by Anthony Garner.

COLORING TECHNIQUES

The audience that loves humorous drawings tends to be very sensitive to the colors used in the characters, their clothing, and the backgrounds and surroundings. The simplest techniques can produce very attractive results, from subdued colors to more intense, opaque, and very detailed treatments.

Color Choice

Color is more than a medium for producing a more naturalistic drawing, for it also provides the observer with information on the character's psychology. The colors that are used in these instances can also be catalogued into specialties. For example, light, bright colors are commonly used for positive characters, while darker, shadowy colors are suited to villains, witches, evil people, and the like.

Light Washes

Watercolor washes in soft, light shades fit in perfectly with the simplicity of line drawings, and mixing the two of them together on the same ground

Because of their ease in mixing and their brilliant colors, watercolors and anilines are the most commonly used media for coloring satirical illustrations.

commonly yields excellent results. One of the greatest advantages of watercolors is the ease of creating areas of diffused color with a single application of paint—just one brush stroke—so that the gradation has complete integrity, with no retouching or repetition. This resource is used for backgrounds intended to set off the illustration's main theme.

Opaque Paints

A complex blending of shapes and colors, which in a realistic mode can be accomplished with opaque colors such as gouache, makes this medium the best one for illustrations in a naturalistic vein. Coloring an illustration with gouache is not much different from using watercolor; in both cases, the idea is to spread out the color dissolved in plenty of water. When the base coat is dry, new shades of the same color can be added on top of the previous ones to begin defining the shapes. Opaque paint doesn't allow for such subtle effects as watercolors do, and the contrasts between light and dark are clearer and sharper.

Drying Times

Watercolors dry rather quickly, especially when applied to very smooth papers or cardboard. If the area to be covered is fairly large, it is preferable to use broader brushes, since they allow working rapidly and keep the brush strokes from showing. If the illustrator needs the

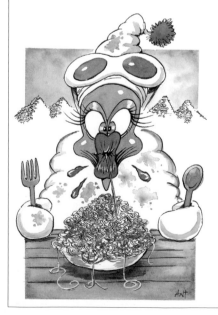

Light washes are used mainly when it's desirable to preserve the lines of an ink drawing. Illustration by Anthony Garner.

a

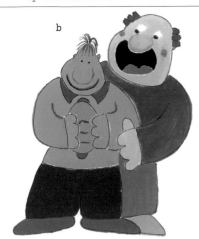

b

colored areas to remain damp longer, a few drops of a retardant like ox gall may be added to the water being used for the work. The work pace is determined by the time it takes the colors to dry; only practice will help the illustrator feel comfortable with the pace imposed by the drying time.

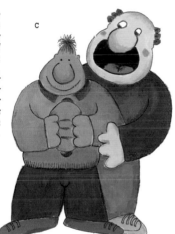

c

Opaque paints such as gouaches have to be applied in a particular sequence: after the initial drawing (a), the main areas are colored in (b), and then, using a smaller brush, the color variations suggested by the shape of the figures are added (c). Illustration by Montse Ascensio.

Coloring with the Computer

This is the easiest way to manipulate colors when inking a drawing. All you have to do is apply new paints to the image using an airbrush tool. One of the most current animation techniques for creating special effects is *morphing*, which requires the use of computer media to give the characters impossible shapes.

The computer resources that exist nowadays are capable of creating coloration that is scarcely distinguishable from hand coloring. Illustration by Sergi Camara.

SPECIAL EFFECTS AND TRICKS

Color washes, using watercolors, gouaches, or acrylics, allow a variety of effects that can give an illustration more artistic interest. In this section we will show some of the most common techniques used by professional illustrators to create different textures.

Wet on Wet

This type of wash involves painting over another wash without waiting for it to dry, or onto a blank paper that has been moistened in advance. The brush glides easily across a damp surface, the paint flows better, and the pigment spreads out freely in all directions. The result is a soft, hazy effect in which the shapes don't stand out sharply from one another, since the colors blend together perfectly. This also means that painting onto a damp surface may produce unpredictable results.

Creating Highlights with Bleach

When working with anilines or liquid watercolors, it's also possible to create interesting effects using bleach. The

Wax resist applied to a drawing of a cat. Illustration by Anthony Garner.

process is simple: first the colored wash is applied, and then we create highlights or lighten the area by painting over it with a little bleach. In a moment, we see that some of the pigment from the wash vanishes, producing interesting artistic effects. The more the bleach is diluted in water, the less it lightens the layer of paint.

Wax Resists

If we make a preliminary drawing with a stick of wax or grease pencil, it will leave a series of fairly grainy lines with a broken effect on the surface

of the paper. Afterwards, when a wash is applied, the wax repels the paint, and the areas coated with wax remain white.

a

b

Various effects created with washes: wet on wet (a and b); highlights opened up with bleach (c); wax resist (d); sprinkling table salt over a damp wash (e).

c

d

e

Washes with Salt

If a light, even wash is applied and a little table salt is sprinkled on it while it's still damp, we see that as the wash dries the grains of salt absorb the pigment and create some interesting spots of light, delicate color. Once the surface of the paper is completely dry, the salt crystals stuck to the paper are simply shaken off.

Scraping

Scraping is another way to open up white areas or create lines on dark backgrounds. This must be done on an area that has just been painted, while the watercolor is still damp. There are two ways to open up these white lines: one involves scraping the surface of the paper firmly with the pointed end of a paintbrush handle; the other is to use the point of a razor blade or a hobby knife. The lines done with a razor blade or hobby knife will be deeper, narrower, and more intense.

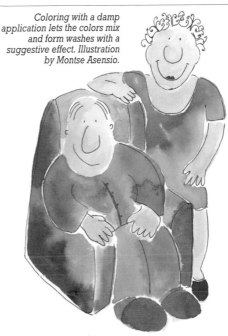

Coloring with a damp application lets the colors mix and form washes with a suggestive effect. Illustration by Montse Asensio.

Exaggeration of Perspective and Foreshortening

In humorous drawing, we are able to create surprising and even unsettling distortions of perception by exaggerating the effects of perspective and using foreshortening in the figures. Bizarre and uncomfortable effects can be achieved by showing scenes from strange angles and manipulating the foreshortening.

In this illustration, the exaggerated perspective of the skyscrapers and the foreshortening of the leg create shapes that have great visual impact. Drawing by Anthony Garner.

CARICATURE

Caricature is a "pseudo portrait" of a person in which certain dominant facial features are exaggerated, emphasizing the peculiarities of the person's outward appearance to produce a generally comical and satirical drawing, or to highlight the person's characteristics or personality flaws.

The Satirical Effect of Caricature

Filippo Bardinucci, one of the most important art critics of the seventeenth century, defines caricature in the following way in his *Dictionary of Art Terms,* published in 1681: "It designates a way of creating portraits in which the artists aspire to the greatest possible resemblance to the person in the portrait; however, for purposes of amusement, and sometimes to make fun of the subject, they exaggerate and place excessive emphasis on the defects of the figures they copy, in such a way that the overall portrait resembles the model, but the component parts are modified." What the Italian critic is trying to say in these lines is that caricatures are based mainly on a process of physical reduction and an exaggeration of the facial features, and that the satirical effect originates in the pleasure that we get from the contrast between the real and the improbable, between the similarity and the likeness.

Human Expressions

Working as a caricaturist requires a good knowledge of human physiognomy and

The most important part of a caricature is the proper positioning of the minimal indications of expression; in the case of Woody Allen, these are surely the shape of the nose and the omnipresent glasses. Illustration by Alfonso Lopez.

In this illustration the artist succeeds in faithfully reflecting both the person's physical features and comical character. Illustration by Anthony Garner.

expression, developing observational skills to help identify the physical peculiarities of every face and understand the psychological aspect of every one of these details and expressions. After all, the caricaturist has to create convincing characters and characterize the models by presenting their main identifying features, their character and attitude, as well as their reactions, and show them in an understandable form that allows any viewer to identify the person in the caricature.

Minimal Indications of Expression

The purpose of caricature is to treat the subject with irony through exaggeration or the distortion of certain dominant details. Every good caricaturist ought to search in the character for what psychologists call "minimal indications of expression." This requires that the artist be a very attentive and demanding observer of reality. Above all, this ability to observe detail, plus skill in

Naturalistic Models

When we find ourselves before a model with fairly normal, regular features, we can resolve the caricature by making a naturalistic drawing that includes a certain amount of deformation, like making the nose or eyes a little larger than normal or changing the shape of the face by making it narrower or longer.

If the person depicted isn't given very exaggerated features, the caricature can be quite naturalistic. Illustration by Manel Puyal.

synthesizing the information— and not so much the technical skills in drawing—are what make it possible to capture and accurately depict the most salient nuances of true caricature.

Psychological caricatures favor a more conceptual drawing over a naturalistic treatment. Illustration by Anthony Garner.

MORE ON THIS TOPIC
• Caricature: Studying the Character **p. 86**

CARICATURE: STUDYING THE CHARACTER

There is a series of creative processes that leads to successful caricature of any given person. They are all learned with experience. It is essential to use these processes to one degree or another to create a caricature that has life, stands out for its professionalism, and achieves widespread appreciation.

Good Photographs

Whenever possible, we should get used to working with at least three photographs of the person to be caricaturized: frontal, side, and three-quarter views. This will help us see the volumetric effect of the figure, and allow us to understand the facial features more clearly. In addition, the photographs will help in contrasting the ongoing process of abstraction with the original model.

Doodles

In getting started in the world of caricature it's not enough to "doodle and see what develops," as the great Swiss caricaturist Rodolphe Töpffer used to say, in an attempt to let the line carry the

Sketches lead to an initial drawing that captures the definitive expression.

artist along in an automatic and intuitive way. Nor was Picasso, another artistic genius, inviting the artist to discover the possibilities of the medium by using a compromised work when he said, "I do not search. I find." The principle of all creation lies in exploration and analysis, at the expense of inspiration and chance. Caricature is based on comical comparison, and any doodle will suffice as long as it possesses a striking resemblance to the prototype.

Abstracting the Most Characteristic Features

What we perceive as a good resemblance in a caricature or even a portrait doesn't need to be a replica of anything we have seen before, but rather the abstraction of a real model. We have to concentrate on the person's most characteristic features, highlight them, and if appropriate, exaggerate them. The degree of exaggeration determines the caricature's satirical effect. If an outstanding detail is observed, such as large ears on a small face, it must be given absolute supremacy.

You have to be bold in doodling; little by little the shapes that define the person emerge.

MORE ON THIS TOPIC
• Basic Elements in Humorous Representation **p. 46**

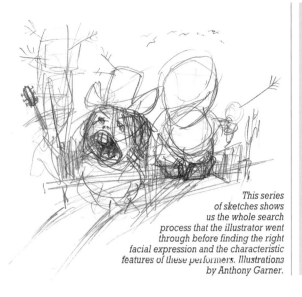

This series of sketches shows us the whole search process that the illustrator went through before finding the right facial expression and the characteristic features of these performers. Illustrations by Anthony Garner.

Capturing the Psychology

Even if we don't completely agree that the face is the mirror of the soul, it is certain that when an artist undertakes a caricature, he or she should take into account the physical features and the psychological makeup, or at least the personality that the model projects publicly. This is done by using controlled but explicit facial expression and support from body language or posture.

Based on a preliminary sketch, a subsequent drawing is done; here's what it looks like once it's inked and colored in. Illustration by Anthony Garner.

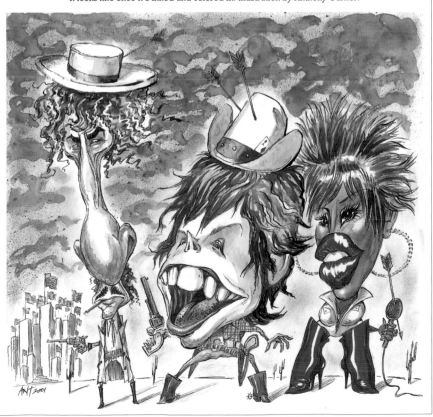

CARICATURE IN PENCIL: WINSTON CHURCHILL

The first caricature we will present is of Winston Churchill, whose unmistakable image is well known to all. The first thing a good caricaturist must do is identify the most characteristic facial features, the ones that allow us to establish a resemblance to the character.

Structure

We can begin with a simple freehand drawing of an oval. On the surface of this oval we draw the axis of symmetry,

We locate the level of the eyes and the position of the shoulders on the oval.

bold, thick lines from a stick of graphite held slightly to one side, we indicate the shape and direction of the eyebrows, the location of the eyes and nose, the straight line of the mouth, the chin, and finally the double chin.

Defining the Most Characteristic Features

Now we begin defining the subject's most characteristic features. We draw the crease of the forehead and the shape of the eyes with firm, bold lines. Then other lines act on the previous ones to shape the nose, the cheeks, and the outline of the mouth. We also have to take into account the prominence of the lower lip.

MORE ON THIS TOPIC

· Caricature **p. 84**

and then we mark off the height of the eyes by drawing a cross. The intersection of the two lines is right in the center of the face. With a couple more lines we suggest the position of the shoulders and the lapel of the jacket.

Basic Construction of the Face

The basic construction of the face involves combining circular shapes, still treated in a very schematic way. Using

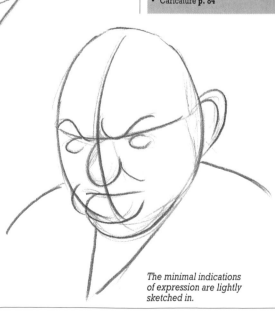

The minimal indications of expression are lightly sketched in.

Caricature: Studying the Character
Caricature in Pencil: Winston Churchill
Caricature in Watercolors: General de Gaulle

89

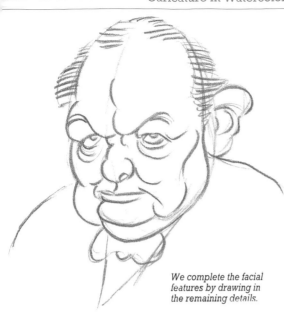

We complete the facial features by drawing in the remaining details.

Three-quarters View

When we draw a caricature, we should avoid a frontal view of the model, since it comes out very symmetrical and monotonous. The best representation is produced with the head in three-quarters position; this assures that the facial features will stand out to best advantage.

of the eyebrows surely infuses character to the statesman whom we all know for his decisive role during the Second World War.

Shading

The caricature is completed by using a pencil to darken the shaded areas of the face and hair, and a graphite stick for the darkest grays of the suit. If we compare the finished drawing to original photographs, which we can surely find in any modern history book, we see that the artist has exaggerated the size of the ear, increased the hardness of the facial features, and reduced the size of the nose with respect to the other facial features; the exaggerated arch

The final features of the face are added, plus the colors of the suit and the hair.

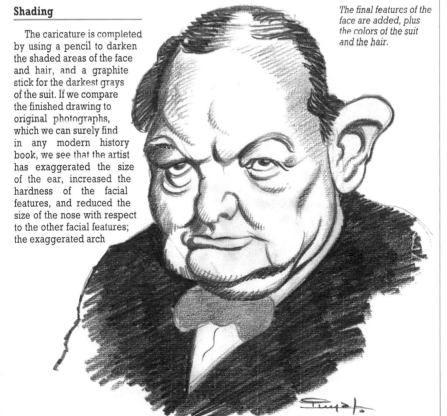

CARICATURE IN WATERCOLORS: GENERAL DE GAULLE

Once the distortion and exaggeration inherent in the caricature have been established, the best approach for drawings that approximate reality is to work with transparent color washes.

Geometrical Layout

We can define the structure of the head using an equilateral triangle. Very simple shapes are the result of a reduction process that starts with more complex shapes. Using more precise outlines, we construct the shape of the head onto the initial triangle, without paying much attention to details. Then we use an eraser to eliminate the geometrical structural lines. Finally, with a very sharp graphite pencil, we refine the character's outline and add new details to the face.

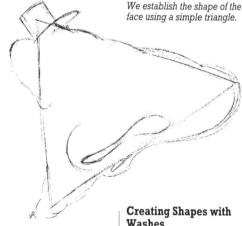

We establish the shape of the face using a simple triangle.

Coloring with Washes

The initial watercolor treatment involves applying washes with the sole purpose of filling in the fleshy areas, the clothing, and the cap with a preliminary color. This will establish an initial coloring that can be further elaborated using other washes. As you can see, these washes are rather monochrome, with hardly any variations in shade.

Creating Shapes with Washes

The lines drawn in pencil are erased. Then we apply some new colors that include more carmine to the tip of the nose and around the nostrils, over the previous washes. With the same color we highlight other shapes and features of the face. Applying watercolors to a caricature always lends a very natural look to the flesh tones and textures.

Outlining with Pen and Ink

New brush strokes painted over old ones, in shades of brown and purple, help emphasize the shape of the nose. A small light-colored area on the tip suggests a reflected light. Next we use olive green to apply a second shade to the suit and the military cap. We apply the finishing touches with a metal nib, which is used in drawing

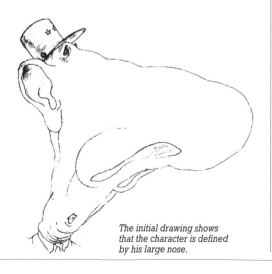

The initial drawing shows that the character is defined by his large nose.

Caricature in Pencil: Winston Churchill
Caricature in Watercolors: General de Gaulle
Caricature in Markers: Marilyn Monroe

91

The first washes tone down the white of the paper; as this illustration shows, they are very transparent.

around the profile of the head. The insides of the nostrils and ears are darkened with cross-hatching, and the moustache is depicted in a comical way. Using an ink pen for the final touches offers an infinite number of expressive possibilities.

New washes contribute to shaping the face. Pink washes are used to set off the shape of the nose.

After adding the color, a pen and India ink are used to go over the outline.

MORE ON THIS TOPIC

- Caricature **p. 84**
- Caricature: Studying the Character **p. 86**

CARICATURE IN MARKERS: MARILYN MONROE

Markers offer a wide range of technical resources in drawing caricatures, from intense lines like the ones drawn with ink to the subdued colors that recall the use of a reed pen and graphite pencil.

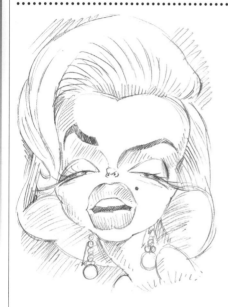

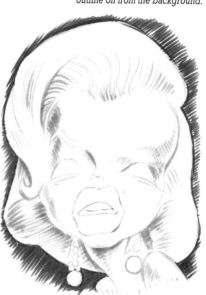

A gray marker is used to set the outline off from the background.

We begin with a pencil sketch of the actress. The drawing should be linear, with no shadows.

Pencil Sketch

The first thing we do is draw a pencil sketch to study the character's main facial features. In this preliminary study, we pay particular attention to the shape of the eyes and the tender, sensual look that emanates from them (exaggerating the length of the eyelashes to make them look more feminine), the voluptuousness and shape of the blonde hair, and especially the size and shape of the lips, accompanied by the actress's characteristic mole. The nose appears very tiny in comparison to the other facial features.

Drawing the Outline

A gray medium-tip marker is used to draw the background in a sweeping motion diagonal to the format of the paper. This technique is based on quick, parallel lines made with the marker, which follow or emphasize the plane of the object. If we add a little water to the ink we can also create a lighter line that is useful in defining the facial features. Sweeping strokes create the directional lines in the hair and the main contrasts between light and shadow.

Highlighting the Features

The caricaturist applies new shades of gray to the background in order to set off the character's outline. Next, the circular shape of the earrings is drawn and the main contrasts in the hair are reinforced with a medium gray. Then a black marker is used to indicate the direction of the eyelids. The lips are colored with red and carmine; note that the small white highlights simulate reflected light. As with watercolors, there is no white color with markers, so the artist has to utilize the white of the paper.

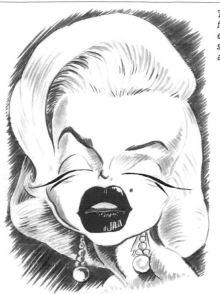

The main facial features are emphasized: sensuous eyes and fleshy lips.

Final Shape and Volume Effects

The finishing touches are not as complex as they may seem; they involve gradually adding new strokes over earlier ones to create the shape and volume of the actress's face. We can use a medium-tip black marker for the linear details, highlighting the shape of the eyebrows, the eyelids, the eyes, and the dark areas of the hair. The largest areas of the background should be done with a broad-tip marker. The most common practice involves using parallel lines, whether horizontal, diagonal, or vertical, drawn quickly enough for the ink at the edge of each line to blend with the next one with hardly any streaks.

Finally, the shapes are gone over with a nearly dry marker to reinforce the effect of shape and volume.

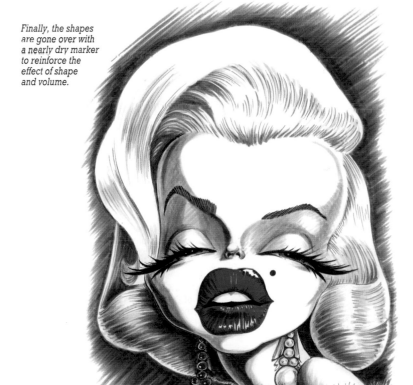

CARICATURE IN INK: ORSON WELLES

The complex nuances of shape and color that can be created with colored inks and a broad selection of brushes makes this medium the best choice for caricatures in the American naturalistic style.

Process of Analysis

The first stage involves a doodle. The artist sketches the model's face several times to discover the most important features, drawing reflexively and exploring the character's features without thinking. Two circles are used to set up the obese shape of the face; the eyes appear half closed, with slanting, arched eyebrows that contribute plenty of character.

In the preliminary pencil sketch, the character reflects intense humanity, with the top of his head compressed and great emphasis on the size and shape of his body. The absence of a neck and waist further accentuate the model's obesity.

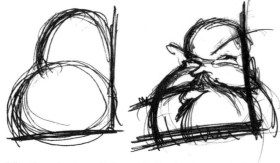

A fine-tip marker is used to lay out the head and communicate the character's obesity.

Preliminary Washes

The flesh tones of the face and hands are applied first, painting over a wet surface using Prussian blue, orange, and lemon yellow inks. Working on a damp surface allows the colors to spread out on the paper and produce smooth color transitions. Small light-colored areas are left to simulate reflected light. The shaded area of the face contains more blue than the rest.

Painting the Clothing

While we are waiting for the first washes to dry, we can paint the character's body. We have decided to give it an abstract treatment that is not very descriptive. Additional brown washes are used to color the area of the beard, the shape of the upper lip, the cigar, and the opening of the ear. A small round brush dipped in Prussian blue is used to outline the facial features with clean, continuous, and loose lines.

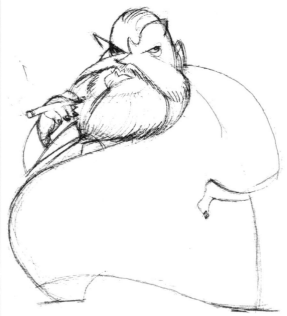

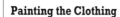

The pencil sketch already shows the psychological aspects of the character's sensitivity and acuity, emphasizing an astute and temperamental expression.

Lines in India Ink

Finally, the artist finishes defining the face, maintaining the cleanliness and precision of the lines. The same fine, round brush that was used earlier and black India ink are used to emphasize the zigzag shape of the eyebrows and the direction of the hair on the head and in the beard. We then draw the outline of the eyes, the nose, the ears, and part of the lips with greater precision, and practically without bending the tip of the brush.

Mixing the inks on a moist surface produces smooth gradations among colors.

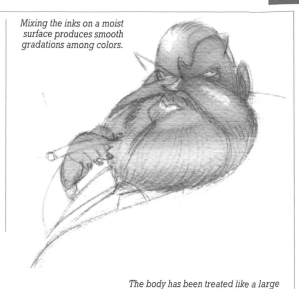

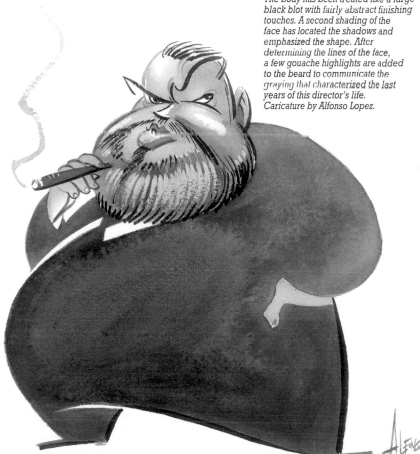

The body has been treated like a large black blot with fairly abstract finishing touches. A second shading of the face has located the shadows and emphasized the shape. After determining the lines of the face, a few gouache highlights are added to the beard to communicate the graying that characterized the last years of this director's life.
Caricature by Alfonso Lopez.

English-language edition for the United States,
its territories and dependencies, and Canada
published 2003 by Barron's Educational Series, Inc.
© Copyright of the English edition 2003
by Barron's Educational Series, Inc.
Original title of the book in Spanish: *Caricatura*
Copyright 2003 by Parramón Ediciones, S.A.—
World Rights
Published by Parramón Ediciones, S.A., Barcelona, Spain

Author: Parramón's Editorial Team
Illustrators: Parramón's Editorial Team

All inquiries should be addressed to:
Barron's Educational Series, Inc.
250 Wireless Boulevard
Hauppauge, NY 11788
http://www.barronseduc.com

International Standard Book Number 0-7641-5359-5

Library of Congress Catalog Card Number 2003103760

Printed in Spain
9 8 7 6 5 4 3 2 1

Note: The titles that appear at the top of the odd-numbered
pages correspond to:

The previous chapter
The current chapter
The following chapter